How to Photograph
BABIES AND CHILDREN

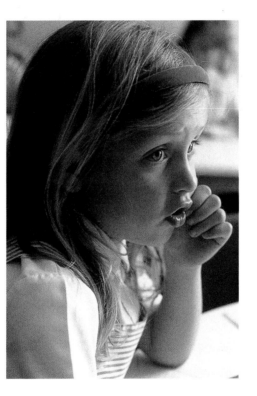

How to Photograph
BABIES AND CHILDREN

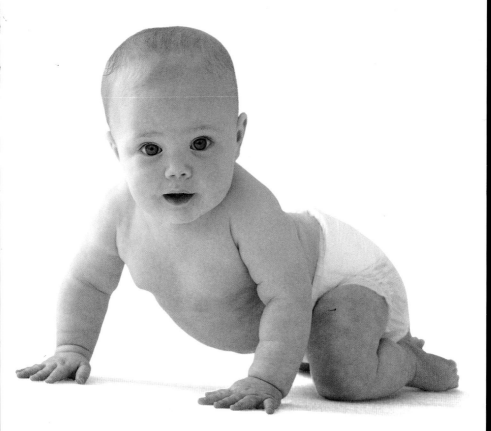

Photographs by ANTHEA SIEVEKING

Text by STEVE PARKER

Kodak
BOOKS

ACKNOWLEDGEMENTS

The photographer and publishers would like to thank all the children in this book, and their parents.

ANTHEA SIEVEKING

Anthea Sieveking is one of the best respected photographers of children and babies, well known for her work on educational and child development books. Her photographs have appeared in many books, including *The Encyclopaedia of Pregnancy and Birth*, a World Health Organisation *Medical Encyclopaedia of Health*, and (for children) *What Colour?*, *My First ABC*, and *Baby's First Year*.

STEVE PARKER

Steve Parker is a photographer and writer specializing in photography and video. He has written for numerous publications, including *Amateur Photographer* and *Practical Photography*. He is the author of *The Collins Camcorder Handbook* (1993).

First published in 1994 in the United States by
Kodak Books, an imprint of Silver Pixel Press,
a division of the Saunders Group, 21 Jet View Drive, Rochester, New York 14624
Reprinted 1995
First published by HarperCollins*Publishers*, London
© Photographs Anthea Sieveking, 1994
© Text Steve Parker, 1994
© Design and illustrations HarperCollins*Publishers* 1994

Edited, designed and typset by Haldane • Mason, London

Kodak Books are published under license by Silver Pixel Press

Steve Parker asserts the moral right to be identified as the author of this work.

Publication AC-230
CAT No. E 130 1000
ISBN 0-87985-752-8

Printed and bound in Italy

PHOTOGRAPHIC ACKNOWLEDGEMENTS

Canon 134; Fleet Photographic 136, 137; Kodak 135; Steve Parker 43, 65 (bottom); Shona Wood 26 (top), 27, 35, 38, 39, 47, 49, 67 (top).

Contents

Introduction 6

Chapter 1: FIRST STEPS 8

Babies 10
Parent and Child 12
Toddlers 14

Schoolchildren 16
Young Teens 18
Children and Pets 20

Group Shots 22
Family Gatherings 24

Chapter 2: THE GREAT OUTDOORS 26

In the Garden 28
Water Games 30
In the Playground 32
Summer Outings 34

On the Farm 36
Horse Riding 38
At the Zoo 40
Carnivals 42
Theme Parks 44

Sports and Games 46
Capturing Action 48
At the Seaside 50
On Vacation 52

Chapter 3: INSIDE STORY 54

Children's Parties 56
Dressing Up 58
Festivals and
Celebrations 60

Musical Instruments 62
Playing Games 64
Ceremonies 66
Dancing 68

School Plays 70
Story Time 72
Bath Time 74
Time for Bed 76

Chapter 4: IMPROVING YOUR SKILL 78

Portrait or Landscape? 80
Composing the Picture 82
Backgrounds 84
Props and Set-up Shots 86
Natural Frames 88

Adding Depth 90
Narrow Focus 92
Wide Focus 94
Focal Length 96
Camera Height 98

Unusual Angles 100
Full-length Shots 102
Close-up Portraits 104
Natural Portraits 106
Formal Portraits 108

Chapter 5: USING COLOR AND FILTERS 110

The Color Wheel 112
Color Association 114
Complementary

Colors 116
Color Saturation 118
Silhouettes 120

Color Filters 122
Effects Filters 124
Black and White 126

Chapter 6: PICTURE PRESENTATION 128

Cropping 130
Display Methods 132

Viewing on TV 134
Photo Gifts 136

Glossary 138
Index 142

Introduction

For many years I have been photographing children and adding to my extensive picture library, from which some of the shots in this book have been drawn.

I have used many types of camera and certainly any of them can be used to take an outstanding photograph. Whether you have a basic compact that makes all the technical decisions for you, or a highly refined SLR system with its collection of lenses, you can take good pictures that you will enjoy for years.

It is, of course, the photographer and not the camera that makes a good photograph. The pictures in this book and the accompanying text are designed to help you to spot or create those moments in family life that we all want to have on film, and then to set about actually doing it.

I do believe that anyone with half an eye can get good pictures. So try it – it's fun.

Anthea Sieveking

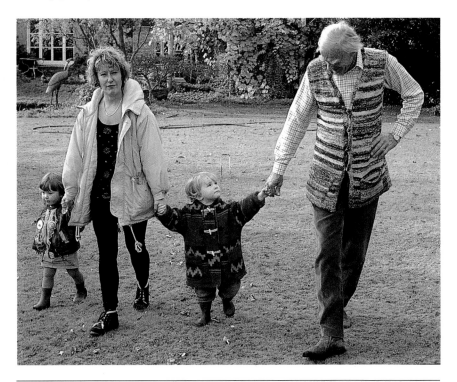

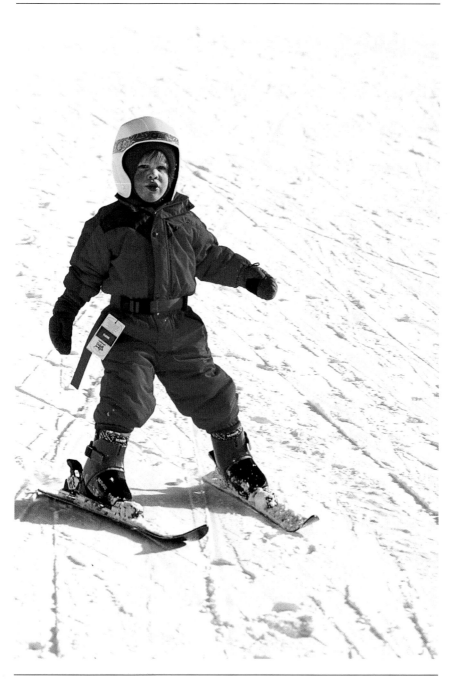

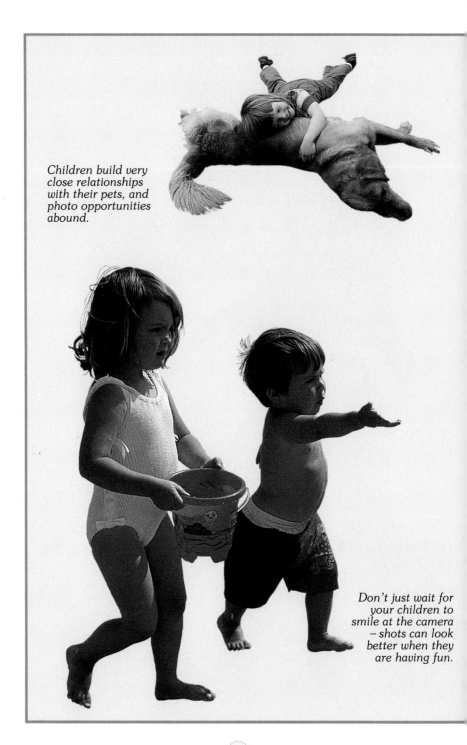

Children build very close relationships with their pets, and photo opportunities abound.

Don't just wait for your children to smile at the camera – shots can look better when they are having fun.

FIRST STEPS

- Babies
- Parent and Child
- Toddlers
- Schoolchildren
- Young Teens
- Children and Pets
- Group Shots
- Family Gatherings

Look for moments of intense concentration, such as when children are learning the basic skills we take for granted.

Don't forget to include other members of the family in your shots – everyone should feature in your photo album.

Babies

You can judge a good photograph by whether people who look at it react to it well. For most people, reaction to a photograph is based on gut feeling. But a viewer's gut feeling may be the result of careful planning and thought on the part of the photographer.

People with a natural affinity for children will always react well to photographs of babies. Babies make ideal subjects because they are expressive, but not self-conscious.

For the best results, wait for the right moment to photograph them. If there is a new baby in the family, you will soon get to know when it is irritable, sleepy, or most relaxed. Try to photograph babies when they feel

These photographs use the roughness of the towels to emphasize the contrasting smooth-ness of the babies' skin. They would be less successful if the children had been photographed against smooth walls or sheets.

most comfortable. Don't try to prop them up into posed positions – if they are not relaxed, this will show.

Natural light

Don't use direct flash if the baby is looking at the camera – particularly with new-born children, where the strong light may be both startling and painful. If you have a camera where the flash fires automatically in low light, place the baby next to a window so that flash isn't necessary.

Learning the basics

A basic knowledge of your camera's important features is invaluable if you want to improve your picture-taking.

Light enters the camera through a lens. Some cameras have lenses built in, while others allow you to fit different lenses on to them. The amount of light that passes from the lens to the interior of the camera is regulated by the aperture.

The aperture

The aperture is a circular opening that can be varied in size. Some cameras allow you to control the aperture size; others change it for you, making it smaller when the light level increases – like the pupil of your eye, which is tiny in sunlight and grows to a big circle at night to let in more light. When you halve the size of the opening, you halve the amount of light that can pass through.

In photography, when you halve the amount of light, you are said to have reduced the amount of light by one 'stop'. If you double the size of the opening, you increase the amount of light by one stop.

The shutter

In between the aperture and the film plane is a shutter. When you press the shutter release to take a photograph, the shutter opens so light can reach the film. This part of the process is known as 'exposing' the film.

Just as the size of the aperture can be varied – to allow more or less light to reach the film – the length of time the shutter is open

can also be varied. The amount of time for which the shutter is open and the film is exposed is known as the shutter speed.

Exposure

If you allow too much light to hit the film, the end photograph will be too light. This is called overexposure. If you don't let in enough light, you will end up with a dark, underexposed image.

Since both the aperture and the shutter speed can be changed on manual cameras, there may be a number of combinations of aperture and shutter speed

that give the same exposure. For instance, if you select a combination that correctly exposes the film, you may be able to double the size of the aperture (open it by one stop), but set twice as fast a shutter speed (decrease exposure by one stop). With an automatic camera, the exposure is decided for you.

Although the result is the same exposure (same amount of light hitting the film), varying the shutter speed and aperture size gives rise to other effects, which can help you take more creative photographs. These effects are explained later.

Parent and Child

Babies and young children often feel more comfortable in the arms of their parents than anywhere else. When you hold your child, you have a good chance of making them feel relaxed so they look happy.

If the child is not feeling cooperative, either wait until later to take the shot, or introduce a favorite toy into the set-up. Even if you are the one who normally takes the photographs, try to find someone else who is prepared to use the camera. If there are two parents, try to get some pictures where both are included.

Fill the frame

The first important rule to learn when you start improving your photography is to make sure your

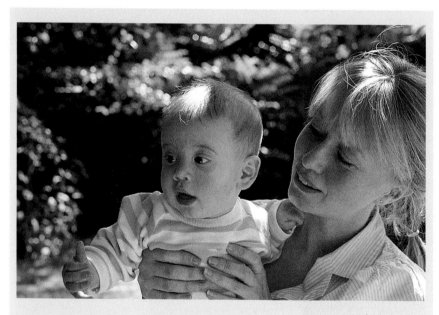

Dappled light

Strong sunlight may give ample light by which to take a photograph, but it can often be very harsh. If the light is behind you, for instance, it might make your subjects squint. A good way of reducing the light – and

producing an attractive effect – is to shoot your subjects standing beneath a tree. The tree should have some leaves, but the foliage should not be so thick that no direct light can filter through.

Ask your subjects to move back and forth slightly until

you see the most appealing dappled effect. Instead of using a tree, if you can find a fallen branch, ask someone else to hold this out of shot, between the sun and the subject. You can then move to a location with a more attractive background to take the shot.

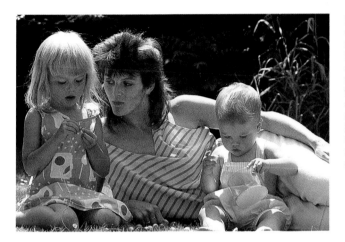

Lying down, the mother's head is brought close to the height of her child's, making a more intimate scene. But if their heads were at the same height, the composition would look too square. As it is, the tops of their heads are joined by a gentle curve.

subjects fill the frame. When you shoot two parents holding their baby, for instance, the background is irrelevant, so crop in tight.

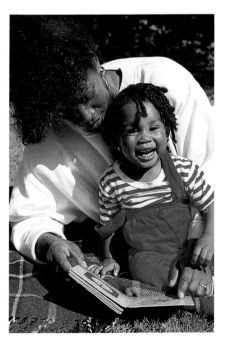

As the baby will be a lot smaller than the parents, you need to crop in tight, so that you miss out most of the parents' bodies and concentrate on their heads and shoulders.

Stand close
Tell the couple to stand very close together – either so their shoulders are touching or so that their bodies are overlapping. Get them to hold the baby between them and to lean their heads towards each other – so there is no enormous gap between their heads.

The heads of the parents and the child should form a triangle – with the triangle filling a large portion of the frame. Just because they are having their photograph taken doesn't mean the parents have to look at the camera – shots of parents and children can look more intimate if they are looking at each other instead.

The child is enjoying a favorite book. Notice how the photographer has cropped in close around the people. Although attractive, the background is irrelevant here.

Toddlers

Toddlers soon become familiar with a camera and what it's for. They also learn very early how to stand as still as a statue and pull a cheesy grin for the camera. Such shots rarely look satisfying, however, and it is generally the more natural poses that work best.

Children grow very rapidly at such an early age, and their interests vary from month to month too. This gives you an ever-changing variety of props and activities to try and capture on film. You will find that new ideas crop up all the time.

You have the opportunity for a few weeks of capturing your toddler's first tentative attempts at walking. You will get a clearer view of their steps if you shoot from the side.

Posed shots

If your toddler is particularly outgoing, though, you may wish to try shooting some posed shots. But rather than getting them to say cheese, tell them to look angry, or cheerful, or even sad.

Having their photograph taken will then seem like fun and games, and you will be rewarded with much better shots than if they associate having their picture taken with having to stand up, back straight with an insincere grin on their faces.

One of the most important and exciting events in a child's early development is learning to walk.

Here, we have stood back far enough to see both the toddler and the people he is walking between.

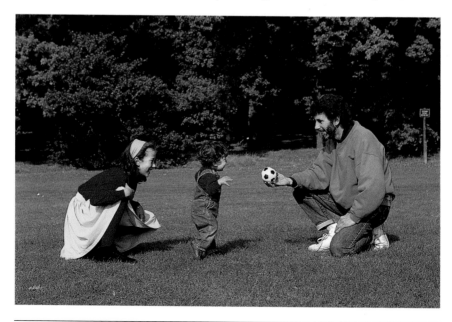

Follow the eyes

The eyes are acknowledged as being the most expressive part of a person. A slight narrowing can imply anger or scepticism; opening suggests excitement or wonder, while slight eye movements can speak volumes about the person we are looking at.

This translates to photographs. When we see a portrait of someone, our eyes invariably come to rest on theirs. If they are looking into the camera's lens, their eyes appear to follow us around as we walk round the room – like the Mona Lisa.

Even when the eyes are not looking directly out at us, their position in the frame is important. If they are looking off to the side, our eyes follow their gaze.

Looking room
As we follow the person's eyes into the photograph, the picture is better composed if there is more room in the direction the person is looking – 'looking room' – than behind them. Most of the space behind them is what artists and photographers term 'redundant space'.

When you come to decide exactly how much looking room to leave, you can follow another artistic guideline called the 'rule of thirds'.

Rule of thirds
The rule of thirds suggests that compositions look better balanced if the important subjects are placed a third of the way into the photograph from the edges of the frame. In

this photograph, for instance, the girl's eye has been placed a third of the way from the top and a third of the way from the right hand edge of the frame.

We have chosen the right hand edge because the girl is facing to the left – this gives her looking room to gaze into. The top of the frame has been chosen because when eyes are placed a third of the way up from the bottom of the frame the head appears to be sinking out of the photograph.

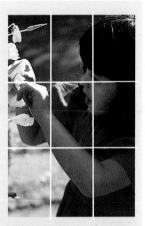

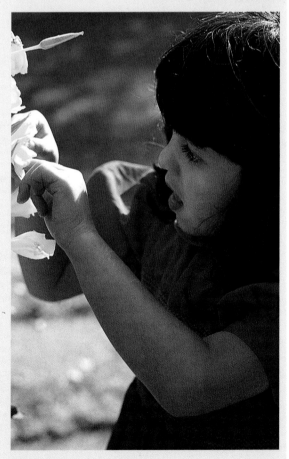

Schoolchildren

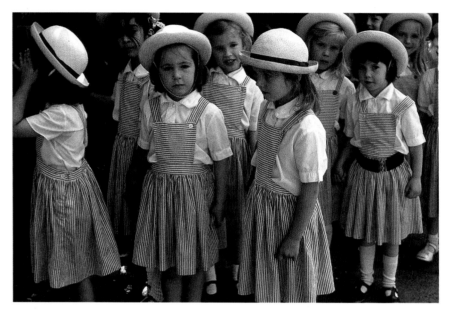

By the time children get to school age, they are very aware of the camera, and at certain ages are likely to be self-conscious about posing for photographs. Rather than a drawback, this can be an advantage. It means you are forced to shoot them engaged in a natural activity, instead of shooting the artificial shots that are best avoided anyway.

It may even be that the best way of getting a good picture is with candid photography. Candids are generally taken when the subjects are not aware they are being photographed – or are at least not expecting a photograph to be taken at that particular moment.

For good candid photography, you must have your camera loaded and

Children in uniform can form an interesting repeating pattern. Notice how your eyes are drawn to the children looking at the camera – particularly the child a third of the way in from the left edge of the picture.

ready to shoot, so that you can grab the opportunity whenever it arises.

For 'grab shots', which occur when you see something happening that you have only a couple of seconds to capture, compact cameras are ideal.

Wide-angle lenses
Even the most basic compacts contain wide-angle lenses. These are lenses that record a much wider view than you see with your eyes – that's why subjects in the viewfinder look smaller than they do with the naked eye.

Because of the way wide-angle lenses are constructed, they ensure most of the scene is fairly sharp – particularly in bright lighting conditions. And since the lenses can record a wide scene, you are likely to capture all of the subject – even if you have only half a second to compose.

Telephoto lenses

For candid shots that you have time to compose, but where the subject does not notice you taking the picture, telephoto lenses are better.

These are lenses that magnify the scene, so that faraway subjects appear close to you. With telephoto lenses you are less likely to be noticed because of your distance from the subject. Some compact cameras have both a wide-angle lens and a telephoto lens built in. Others have zoom lenses that allow you to select any setting between wide-angle and telephoto.

Most single lens reflex cameras (SLRs) have interchangeable lenses – the lens can be removed from the camera and replaced by a different type of lens. Autofocus cameras – those that make sure the subject is in focus automatically – are better for candid portraits.

If you get the opportunity to visit your child's school, you may be able to photograph children engaged in school activities. When they are occupied, candid photography is easy.

Just as smooth subjects stand out against textured backgrounds, so subjects with curved lines – such as people – stand out against backgrounds that contain straight edges. Classrooms are full of straight edges and, despite the clutter, can make excellent settings.

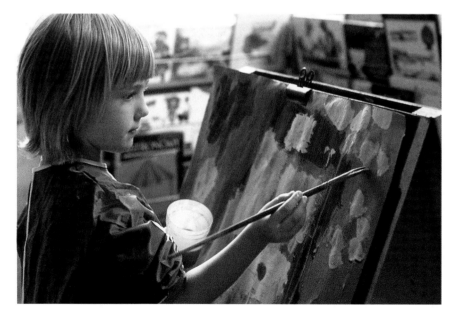

Young Teens

By the time children have reached their young teens, they probably have their own ideas about how they want to be photographed. If you want to take a formal photograph of them, let them get involved in deciding how they want to pose and what they want to wear.

If you are shooting indoors, try to use window light rather than direct flash. Flash gives very flat lighting, with no contrast between light and shadows. For people with wrinkles it can be quite flattering, as it eliminates the shadows in facial creases. But such flattery is unnecessary for a child's smooth skin.

Modelling light

When light falls from the side, facial features, such as the nose and cheekbones, cast shadows on the side of the face away from the light. The shadows help to define the features on the face. In photography, this is known as modelling.

If the light source is very bright, the contrast between the bright highlights and the deep shadows may be very great. This can look dramatic, but for everyday portraits it may be too dramatic. On a bright day, try softening the light by placing a net curtain over the window.

If the window appears in the shot – say at the side of the picture – it may trick the camera into thinking the overall scene is brighter than it is. In this case, an automatic camera can produce an underexposed subject.

Many automatic cameras combat this problem with a button marked BLC (backlight compensation). When pressed, this lets more light on to the film to expose the subject better.

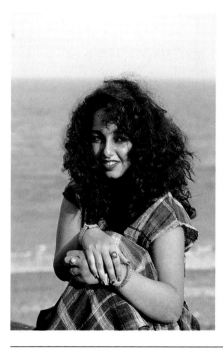

Left: Sidelighting adds detail to the face in this shot. Notice how the girl's tan and the blue of her clothes and rings are mirrored by the location.

Right: Notice how the side light from the window has cast shadows on the side of the subject's face. The contrast between the highlights and shadows helps define the shape of the face. With flash, the shape of the cheekbone would have disappeared, as the whole face would have been evenly lit.

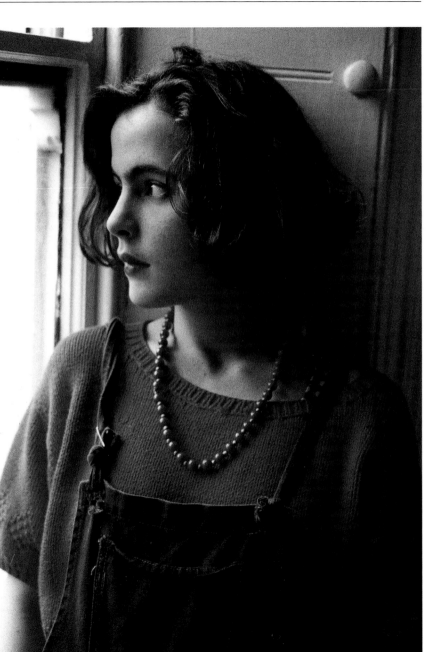

Children and Pets

Pets are often considered a part of the family. If your child has a pet of his or her own, then photographs of the two of them together are a must. Children and animals can play together for hours, so opportunities for good photographs should arise easily.

Most pets have habits that are predictable, and this makes choosing the best time to photograph them easy. If your child and pet play together in a set way, think of the activities that make you smile – these will probably make the best pictures.

There are two main kinds of photograph involving children and their pets. One is the set portrait, and the other involves more natural shots of them playing together.

Formal shots

For formal shots, the child and the animal should be as close together as possible. If the animal is small, such as a kitten or puppy, the child may be able to carry it. But make sure the pet is comfortable – if the animal is struggling to get free, you won't end up with a good portrait.

Try to arrange them so the pet is facing the child. If the animal's face is rubbing up against your child's, the portrait looks a lot more intimate than if the animal is facing away.

High-contrast subjects

Before an automatic camera records a photograph, it measures the light in the scene and sets an appropriate aperture and shutter speed to expose the subject correctly.

In scenes where the light level is fairly even, the camera will normally expose correctly. When there is high contrast between light and shadow, such as here, you have to choose manually whether to expose the highlights correctly (in which case all detail is lost in the shadows) or to expose for the shadows (in which case the highlights become too bright).

An automatic camera would choose a middle setting, but here the highlights have been exposed for, which renders the shadows black. This is because overbright highlights look less attractive than deep shadows. Overbright highlights are called hotspots, and they generally look like mistakes.

If you can set the exposure manually (by altering the shutter speed and aperture), exposing for the highlights often produces the best results.

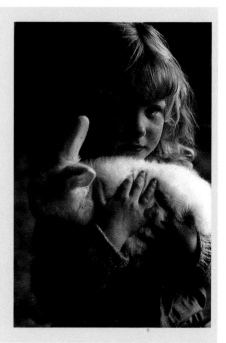

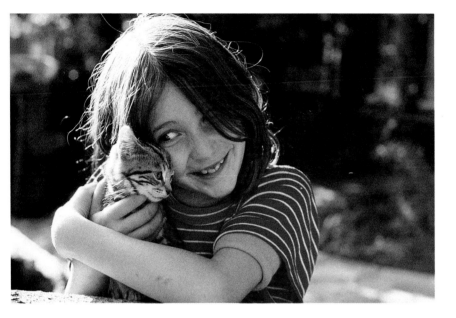

Children and animals are both shorter than you are, and shots taken from above lack the intimacy of shots taken from a subject's own height. Crouch down to take the portrait, so that the camera is at their eye level.

Above: This informal portrait of the child and her kitten works because the kitten is facing towards the child. Had the kitten decided to face in the other direction – looking away from the child – the contact between them would have been lost.

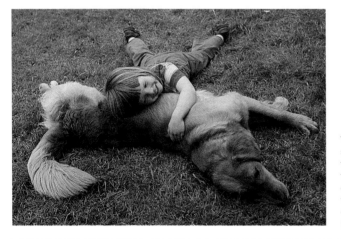

This shot clearly shows the affection that the child and the dog feel for each other. The picture was taken when the child was looking happiest.

Group Shots

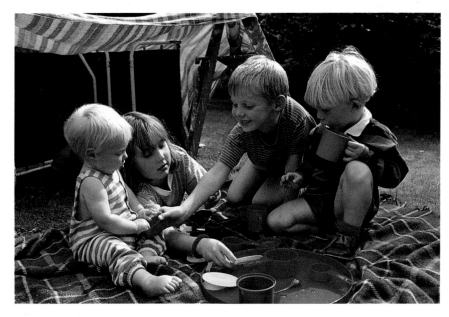

When photographing groups of children, make sure they are relaxed before you begin. Fortunately, when children are being photographed in groups, they are less likely to be self-conscious about posing for a camera. You often see interesting scenes when children are involved in a particular activity – such as having a mock tea party, like the group at the top of this page.

Looking in

Although it is tempting to compose the group so that everyone is facing the front, you may achieve a more natural composition if the children look into the picture slightly. Notice how, in the above photograph, the children are all

This group shot may look natural, but the composition is pleasing because all the children are looking into the shot. Were one of the children to be looking out of the frame, anyone viewing the photograph would follow the child's eyeline out of the picture.

facing a point just to the left of the centre of the photograph.

This is the focal point. Even when there are a number of subjects in a scene, you should still try to find a focal point – a place where the eye comes to rest. Take a look at the above photograph again. No matter which subject you look at, the child's eyes lead you back into the picture.

Now imagine the boy on the right had turned his head so he was looking

out of the frame. Anybody looking at the photograph would naturally follow his eyes out of the picture. The composition would become unbalanced, and the photograph less successful.

Even when shooting formal group shots where the children are looking at the camera, aim for a more interesting composition than simply standing the children in a line.

Position them close together so there aren't gaps between them and vary their head heights. If the children are roughly the same height, get one to kneel or sit on a chair.

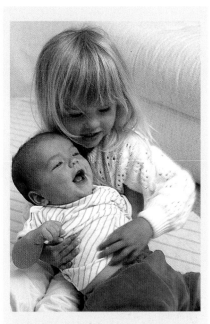

For this posed shot, the children have been grouped in an unusual composition to make the photograph more interesting than a standard line-up. Several shots were taken to ensure all the expressions were right.

High-key portrait

A high-key photograph consists mainly of white tones. Such pictures have a delicacy about them that makes them popular for shots of young children. Lighting should be soft – for example, a flash bounced off a white ceiling.

Diffused sunlight

For close-up portraits, soft sidelighting is often desirable because it produces highlights and shadows on the face – creating what is known as modelling. However, for group portraits, more even lighting is desirable, as directional light may cause one child's face to be in shadow, while another's is directly lit by the sun. When outside, the best lighting is diffused daylight – such as you find on a sunny day when the sun passes behind a cloud. As soon as clouds obscure the sun, the highlights and shadows disappear.

Family Gatherings

Family get-togethers are the ideal opportunity to reach for your camera and take a picture of everyone together. Like all portraits, you can opt for either the formal approach or an informal feel.

When there are lots of people, it is usually best to shoot a formal portrait, otherwise the photograph can look messy. Line everyone up with the tallest at the back and the children at the front. Senior members of the family can be seated in the centre of the shot.

The problem with such set-ups is that someone always has to take the photograph. If that's generally you, it probably means you don't appear in as many family shots as you'd like.

One solution is to use a tripod and a self-timer. Most cameras offer a self-timer facility. Compose the shot, press the self-timer button and rush to your position. You have several seconds before the shutter release fires.

Twin self-timer

Some cameras offer a twin self-timer facility. This takes one photograph, then takes a second shortly after. The idea here is that most people look a bit stiff on formal portraits, but relax as soon as the picture is taken. The second shot captures the relaxed look. As with all portraits of lots of people, take a few shots with the hope of capturing at least one moment when someone isn't blinking or pulling an odd face.

When you take photographs indoors, you may have a problem with red-eye – where reflected flash light causes the pupil to look red. Red-eye occurs only when the angle between the flash, the subject's eye and the lens is small – less than 2°.

Indirect flash

When you have a large number of people looking at the camera, one of the best ways of eliminating red-eye is not to use direct flash. If the ceiling is low and white and your camera and flash allow it, you can point the light up so that it is reflected – or bounced – down off the ceiling.

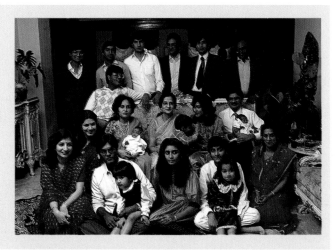

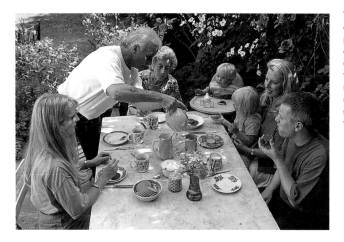

This family sitting outside makes a pleasant scene, but if everyone was sitting down, the centre of the shot would have seemed empty. The man pouring the tea gives the picture a focal point.

This means you can eliminate red-eye by using a flash gun that is further away from the lens – such as the add-on type that can be bought for SLR cameras. Some cameras offer a facility to reduce red-eye.

Below: A less formal approach to shooting a family portrait. Again, notice how the eyelines keep the viewer's eye in the photograph. The father's eyeline leads you to the baby, while the mother and daughter are looking at each other.

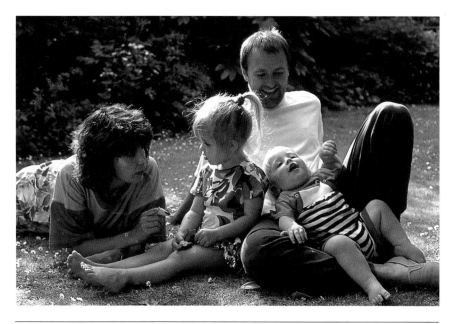

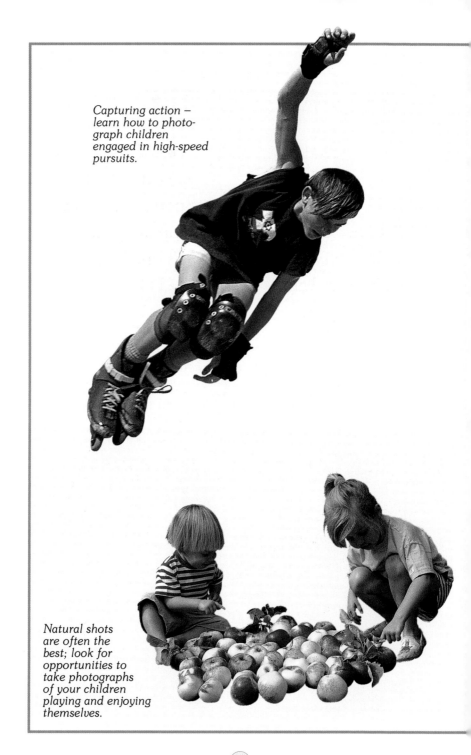

Capturing action – learn how to photograph children engaged in high-speed pursuits.

Natural shots are often the best; look for opportunities to take photographs of your children playing and enjoying themselves.

Chapter 2
THE GREAT OUTDOORS

- In the Garden
- Water Games
- In the Playground
- Summer Outings
- On the Farm
- Horse Riding
- At the Zoo

- Carnivals
- Theme Parks
- Sports and Games
- Capturing Action
- At the Seaside
- On Vacation

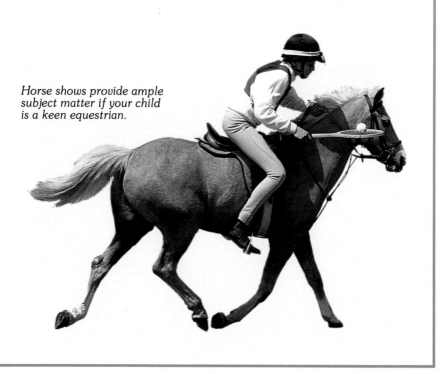

Horse shows provide ample subject matter if your child is a keen equestrian.

In the Garden

One of the most natural settings for shots of your children is in the garden. There is plenty of light, the surroundings are often pleasant, and children can play there for hours.

When photographing, pay careful attention to the background, as well as to the subjects themselves. Look for the most picturesque views in the garden – but don't include anything that will draw attention away from the child, such as bright flowers. Plain foliage makes an attractive backdrop.

Photos taken outside in sunlight can vary greatly, depending on the weather conditions and the time of day you take the photograph. Direct sunlight adds warmth to a shot, while colors tend to look subdued on a cloudy day.

Early morning
On sunny mornings, the sun may cast long shadows, but the contrast between highlights and shadow areas is relatively mild. When the sun is low in the sky, try experimenting with the position of the sun.

If you place it behind you, it will evenly illuminate your subject – but if they are looking directly at you, the sun might cause them to squint. And,

The red of this little girl's outfit contrasts strongly with the green background. The shot uses classic rule of thirds composition – the child is placed a third of the way in from the edge of the frame, with more space in front of than behind her.

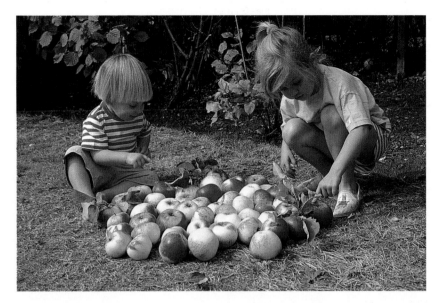

Natural goodness

Often, the best photographs of children are taken when they are concentrating on some activity, rather than when they are posing for the camera. In most gardens there are plenty of things to occupy their attention. Either wait until they are engaged in an activity of their own devising, or suggest a game yourself.

Getting involved
Here the children were asked to collect all the apples together. They were soon so involved that they forgot about the camera.

Be careful when your subjects don't occupy the centre of the frame – some cameras will then focus on the background. You may have to recompose the shot.

of course, your shadow may appear in the picture.

The sun behind your subject creates an attractive halo around their head and shoulders – but be careful not to shoot directly into the sun. If you are using a telephoto lens, which will magnify the image, you can damage your eyes.

Lens flare
Even if you are using a wide-angle lens, like those built into most compact cameras, an overbright background might silhouette the subject. In addition, including the sun in the shot may cause its light to spread into other parts of the image. This is known as lens flare.

By noon, the sun is much higher in the sky. In summer, it may even be overhead. Shadows are a lot shorter than in the early morning, but are much deeper, with marked contrast between highlights and shadows.

In the late afternoon, the sun's light starts to get warmer, so that pale complexions look golden. Shortly before sunset, you will be able to photograph directly into the sun without the light flaring across the rest of the image.

Water Games

In the summertime, the best way of avoiding the heat is to immerse yourself in cool water. Grown-ups might need a whole swimming pool, but for young children a tiny paddling pool is sufficient.

Paddling pools are generally brought out only on warm, sunny days, when the sun is likely to be fairly high in the sky – as it is through much of the late morning and early afternoon during the summer.

In this shot, the camera has been turned on its side to produce what is known as a 'portrait' format shot. When the camera is held normally, such as for the shot on the opposite page, the resulting image is known as 'landscape' format. Portrait format was used in this instance to include the foreground.

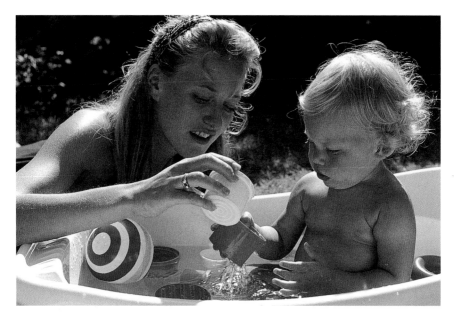

Top lighting

When the main light source is above the subject, the scene is said to be top lit. Top lighting isn't always the best light, because it can create deep shadows in the eye sockets and below the chin. However, it does produce a bright halo around the head and shoulders, which helps pick the subject out from the background.

If you let the children play with a hosepipe, you may be able to shoot some good action shots of them playing. If you have a manual SLR, experiment with fast and slow shutters. A fast shutter speed, say $\frac{1}{500}$ sec, will freeze the water droplets.

With a slower shutter, say $\frac{1}{30}$ sec, the water will blur. This gives a much greater impression of movement, but if the children are moving around quickly, they may blur slightly too.

Notice how the sun overhead has resulted in the classic top lighting halo on both the mother's and baby's shoulders and head. The white pool sides and the highly reflective water bounce the sunlight back up at the mother and baby to soften harsh shadows in their eye sockets and below their chins. If you shoot a close-up of the water, don't include the sun's reflection – it may be distractingly bright.

All-weather friends

When you are taking photographs of excited children splashing around, you have to be careful not to get water on your equipment. Many modern cameras contain very sophisticated computer chips, and these can be easily affected by water getting on to the camera. If you use a compact, and are looking to buy a new one, there are a number of models on the market that boast weatherproofing. Or use the KODAK FUN SAVER WEEKEND 35 Camera.

In the Playground

For young children, heading off down to the park or the local playground is a special treat. Although there will be no shortage of fun scenes to photograph, getting a good shot can be quite difficult, as your child is likely to be running around constantly.

Framing the shot should be fairly simple, but the main problem you are likely to come up against is focusing the camera so the subject is sharp. When you look through the viewfinder of an SLR, you are actually looking through the lens, so you can see whether the subject is sharp or not.

Compact cameras are different. Their viewfinders are simply pieces of glass or plastic that enable you to compose the image. They cannot show you if the image is sharp.

Although you can't focus most compacts manually, a little knowledge of how their focusing systems work can help you ensure sharper images.

Autofocus cameras

The cheapest cameras use a system known as fixed focus or focus free. With these cameras, the lens is permanently focused on a point about 4 m (12 ft) away. A lot of the scene in front of and behind this point is also sharp, so subjects only 2 m (6 ft) away or in the far distance will still be acceptably sharp, but the crispest pictures are taken when you are around 4 m (12 ft) from the subject.

Autofocus (AF) compacts can focus on two or more distances. Each

When the subject is moving around quickly, focusing can be tricky. Most autofocus compacts can handle slow-moving subjects – as long as you keep the main subject in the center of the frame.

distance the lens can focus on is known as a focusing step. Basic AF compacts have only two focusing steps (one at 4 m and one at around 2 m for closer subjects). More advanced zoom compacts have hundreds – check your camera's instruction manual.

The camera's focusing system measures the distance from the lens to the closest subject in the center of the frame. It then focuses the lens to the focusing step closest to that distance,

Shooting from the hip

Your child might sometimes either get self-conscious or start playing up to the camera. With a compact you can literally 'shoot from the hip' without putting the camera to your eye. The wide-angle lens and autofocus system ensures your subject is sharp.

ensuring the subject is fairly sharp. Some advanced compacts can detect subjects not in the center of the frame and focus on the closest. Check your manual – if yours cannot do this, keep your subject in the center of the frame at all times.

When you use a basic compact camera with a wide-angle lens, subjects very close to the lens may be blurred. But if you are shooting a group several metres away from the camera, the focusing system ensures the children are acceptably sharp.

Summer Outings

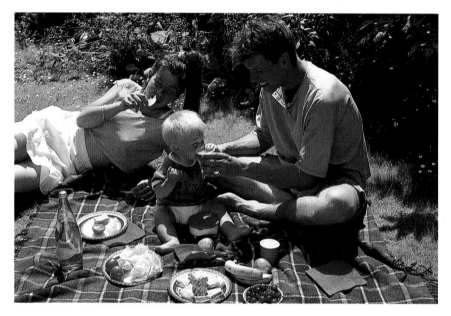

A t the height of summer, what better way of spending a few hours than to drive out to a beauty spot, lay down your blanket and settle in for an afternoon's picnicking?

Before you head off, check photographic magazines or a specialist book that lists events first. It may be that there is a specific event that would serve as an attractive backdrop to your weekend relaxation.

Summer events

Throughout the summer, for instance, you will find numerous regattas, fairs, shows and fêtes, all of which make marvellous family days out – and offer excellent photo-opportunities in themselves.

An idyllic scene – but the shot was taken right at the start of the picnic, before everything began to look messy. The intimate feel comes from holding the camera at the same height as the picnickers' heads.

Historical societies may re-enact famous episodes from the country's history. There may be an opportunity for your children to become involved – either through passive activities, such as having their faces painted, or by being taught the basics of an ancient craft.

Once you have laid the picnic blanket down and spread out the food, take a few photographs immediately. It's surprising how quickly the idyllic scene gets cluttered up with screwed up napkins and leftover food.

On reflection

On hot sunny days, the light from the sun can be very harsh. We have already seen that when a subject is lit by a strong, single light source, all the areas that are touched by the light rays are very bright, whereas all those that are shielded are in deep shadow.

High contrast

This difference between light and shadow is both useful and desirable. It helps to add detail to a shot by emphasizing the borders between areas of light and shade. On bright days, however, the contrast between light and dark can be too much.

The best way of handling this is to even out the light and shadow areas, by providing a bit of extra light to lift the very dark parts of the subject. One way of doing this is to use a reflector.

Notice how, in the top photograph here, the sun is coming from the top left-hand corner of the frame, creating a very dark shadow on the other side of the child's face.

In the bottom photograph, a reflector was placed out of the shot, near the bottom right-hand corner of the frame. The reflector is angled so that light from the sun hits it, and is then bounced back into the

shadow areas below the boy's chin.

Improvised reflectors

If you don't want to carry extra equipment, you can produce makeshift reflectors easily. A piece of silver foil, screwed up then rolled flat again, works perfectly well and can be carried about in a handbag. Newspapers work fine too.

You can warm up or cool down the image by the choice of material you use for a reflector. Some photographic reflectors have a white side and a gold side – using the gold side gives people a healthy glow.

Be careful not to reflect the light directly into the child's eyes, as this can be uncomfortable and will cause the child to squint.

Crouch down to shoot the picnic, so you are at the same level as your subjects. This can look particularly good if there is an uncluttered but picturesque background.

Very small children may try to help lay out the blanket and open the hamper. They are unlikely to speed up the process, but their attempts can be amusing – and photogenic.

On the Farm

At one time there were only a handful of farms that catered for visitors, but more and more working farms and wildlife preserves are springing up and becoming popular.

Most let you get close to the animals, and you may even be allowed to pet them or feed them. Some also offer tractors and combine harvesters for children to climb aboard – these are often as popular as the animals.

Find out when the animals are at their liveliest, and check whether there are any young animals at the farm – these are almost always the most photogenic.

When you see a likely subject, turn the camera on and get ready to shoot. But don't take the picture straight away – by keeping the camera to your eye, you might be rewarded with a really magical moment.

Look at the photograph of the child and the lamb at the bottom of this page. For a while, the two were looking at each other, which made an interesting scene in itself.

The girl is, of course, used to having her picture taken, so she didn't react to the sound of the shutter opening. But the lamb reacted immediately – by turning to face the camera. The second shot made a better photo.

This shot gives the impression that the lamb is actually posing for the camera, while the child is only interested in looking at the lamb. Its success lies in a careful combination of design and luck.

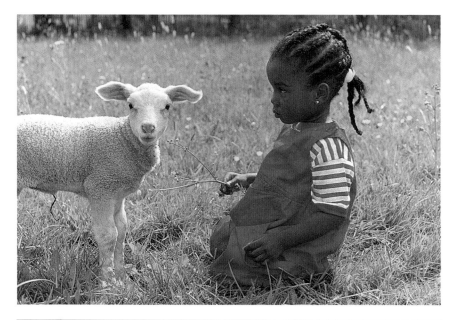

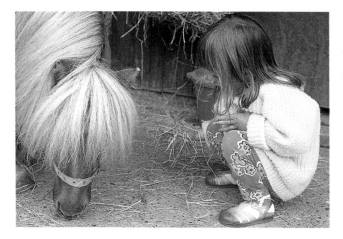

Even if the animals aren't doing anything particularly interesting, you can arouse their attention by feeding them. Don't feed animals, however, unless you are specifically told it's all right for you to do so.

Some of the activities at the farm will take place indoors – in barns and in stables – and here you might encounter lighting problems.

In cattle sheds, for instance, there are likely to be a number of windows or openings. Look for the well-lit places before you start. If you can get away with using natural daylight, the shots will have a lot more atmosphere than those with flash.

Treat with care

Make sure you pay strict attention to any instructions given you by people who work on the farm. This is particularly important when you are dealing with baby animals – not only are they likely to be startled by loud noises and clumsiness, but you might cause distress to their mothers. Don't let your children run off unsupervised – there may be dangerous equipment around.

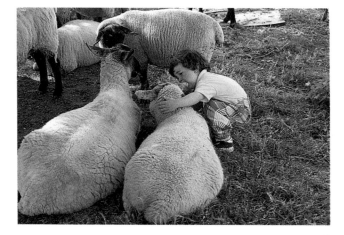

Aim to take natural-looking photographs – even if this means waiting two or three minutes. The perfect moment has been captured here, as the boy seems to be whispering into the sheep's ear.

Horse Riding

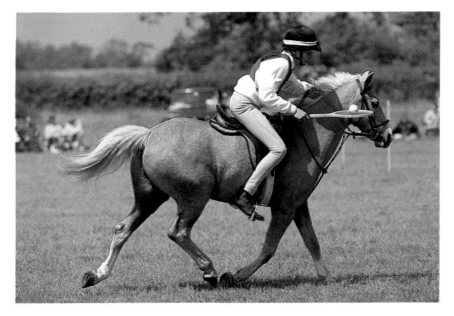

If you own a horse, or your child rides horses, you will have plenty of opportunities to photograph them together. Apart from informal portraits of your child with the horse, there are hundreds of equestrian events you can attend – from small gatherings to major horse shows.

When your child takes part in an event, it is often difficult to stand close to them as they ride around the course. You may need to use a longer, telephoto lens if you want them to fill the frame.

Depth of field

Whenever you focus on a particular distance, some of the scene in front of and behind this point is sharp too. The

In this equestrian egg-and-spoon race, the rider was kept in the centre of the camera's viewfinder as she carried the tennis ball. At the point where she passed the camera, the shutter was released.

distance between the nearest and the furthest points that are sharp is known as the depth of field.

With telephoto lenses, the depth of field is a lot narrower than with wide-angle lenses, so focusing has to be very accurate – otherwise the subject will be blurred.

For the best action shots, compose the scene first and wait for your child and the horse to enter the frame. Choose an interesting piece of action, such as the horse jumping over a fence. If you are using an SLR, focus

No flashing

When you are shooting at equestrian events, all the good photo-opportunities should take place outside, where there is plenty of light. In some circumstances, such as when the horse is in a stable or in its box, there may not be enough light to take a photograph.

If this is the case, don't use flash to boost the light level, as this may startle the horse. One option is to use faster film. Every film has an ISO number, such as ISO 100 or ISO 400. The higher the number, the more reactive the film is to light, and the darker the conditions it can be used in.

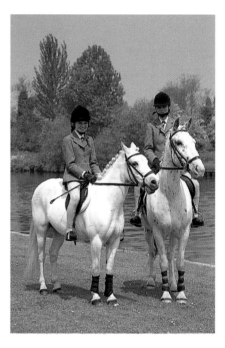

on the fence and shoot as the horse and rider jump.

Portrait opportunity

Equestrian events are also good for capturing formal portraits, as both the horse and child will be well groomed.

If the potential backgrounds are all cluttered and unattractive, stand close to your subject, so the camera is pointing up at the child.

With the horses well groomed and the children smartly dressed, all that was left was to find an attractive background. A wide-angle lens was used to ensure both horses and riders are sharp.

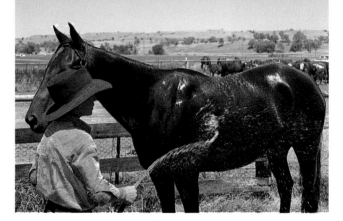

Horses take some looking after, so watch out for good photo-opportunities when your child is grooming or cleaning the animal. Unlike most animals, horses' heads are at roughly the same height as people's, so there is no need to crouch down to get a good picture.

At the Zoo

Zoos present particular problems for photographers, as many of the animals are either kept in cages or are too far away to photograph easily without a long telephoto lens.

Fortunately, many zoos are now moving away from keeping the animals in cages the whole time. Those animals that are both non-aggressive and are happy around people are presented to visitors at particular times throughout the day.

These sessions are often combined with educational presentations, where visitors have the opportunity to learn about the animal's lifestyle and natural habitat. Such displays and presentations represent the best opportunity for you to photograph your children with the animals.

Young animals

When you arrive at the zoo, buy a program that gives you the feeding times of the animals, and tells you when any special presentations are taking place.

It is often best to arrive early. This way you don't miss any of the interesting events, but you may avoid the worst of the crowds.

The best photo-opportunities are at the sessions laid on for visitors to get close to the animals. There may be many people trying to meet the animals at the same time, which can lead to cluttered back-grounds. Here the boy's arm bridges the gap between the two centers of interest.

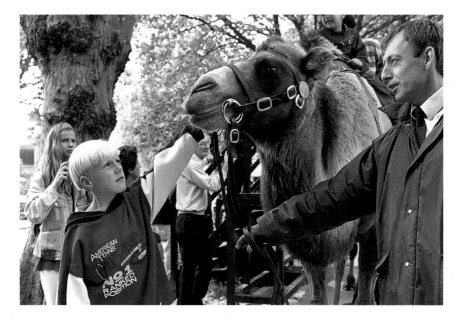

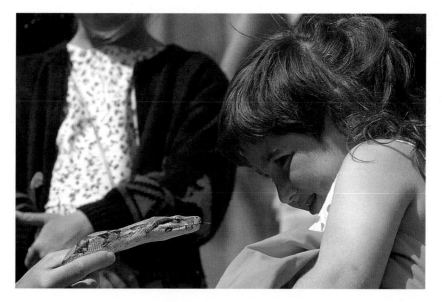

Crop in close

It's not only the cute animals that make good subjects. This child's fascination with the creepier elements of the animal kingdom also makes an excellent photograph. The secret to a shot like this is to crop in very tight on the subjects – here the child's face and the snake's head.

With a standard wide-angle lens on a compact, you would not be able to get this close – you would have to be less than a metre (3 feet) away and the focusing system would not be able to cope. Some compacts offer a close-up 'macro' setting.

SLR lenses have minimum focusing distances. You can experiment to see which of your lenses gives the greater image size – telephotos often can't focus as close as wide-angles, but offer greater magnification.

Ask when you arrive whether there have been any animals born at the zoo in recent weeks. Young animals represent the best photographic opportunity a zoo has to offer, and if the baby animal is ready to meet its public, there may be special sessions to meet it, in addition to those mentioned in the program.

Getting close to larger animals

At some zoos it is possible to get very close to the animals, particularly the larger ones, such as elephants or camels. If your child is close to the animal's head, crop in tightly. If you want to emphasize the size of the animal, however, step back and include its entire body in the frame.

If you are very lucky, your child might have the opportunity of feeding one of the animals. Some creatures, such as sea lions, appear to enjoy putting on a show – generally for some fishy reward.

A shot of your child handing over a fish can make an excellent picture – but, as with any photograph to do with water, make sure you don't get your camera wet.

Carnivals

Street carnivals are often the culmination of weeks – or even months – of preparation. Hundreds of colorful costumes are made, floats are prepared, and regular bands are drafted in to entertain the crowds.

If you and your family are not taking part, but are simply visiting the festivities, try and arrive as early as possible. By late afternoon, most carnivals are packed, and getting good photographs may be difficult.

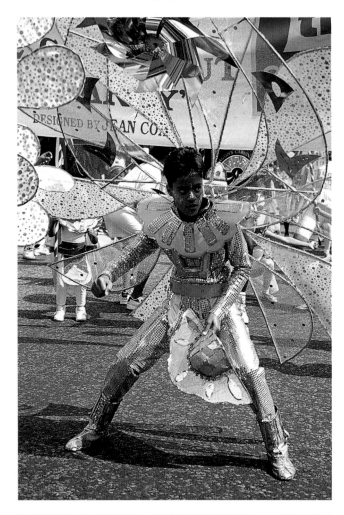

Don't just shoot as soon as you see a photogenic subject. As this boy was dancing, it was best to keep him framed in the viewfinder until he struck a really interesting pose. Only then was the photograph taken.

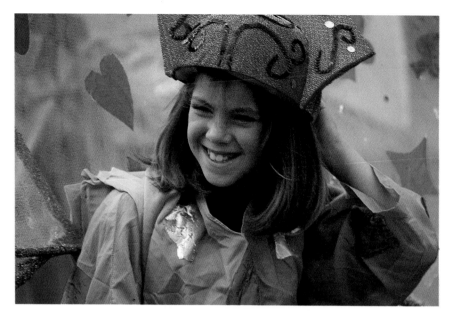

Above: A good shot can be ruined by a cluttered background. Here, the background is entirely made up of her own and other people's costumes.

Right: Match the format to the subject. With this full-length shot, the camera was turned on its side for a 'portrait' format.

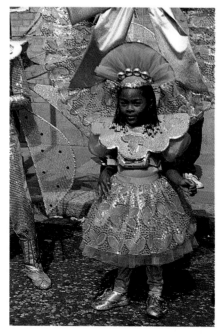

Find out if there is a timetable of events beforehand. Some carnivals have dedicated children's parades, and you should arrive before the parade starts, so you can take photographs of the children getting ready to march.

Zoom lenses

Zoom lenses come into their own at carnivals. There are so many interesting subjects, but often the backgrounds are cluttered and distracting. In this case, you should zoom in and use a telephoto lens to crop out the background.

Theme Parks

Theme parks represent a special treat for children, but despite all the fun to be had, taking good photographs can be difficult – some of the rides go very fast.

When standing on the ground, photographing children enjoying themselves on one of the attractions, the best time to take a good picture is just as the ride starts or just before it stops. This way you are more likely to frame the shot correctly, and you will have less difficulty focusing.

Tell your children where you intend to take a picture, and ask them to wave as they reach that point. If you are using a manual focus camera, prefocus the lens on that point, then take the shot as the children reach it.

You can often shoot better photographs if you climb aboard the ride yourself, taking the horse, vehicle or seat in front of your children. Focusing is easier – because the distance between you and them is constant – and the shot often looks more dramatic.

Some theme parks have notices warning you against taking your camera on fast rides, and reminding you that if you take photographs on the ride, it is at your own risk.

Some rides are best photographed at a particular time of day. Dodgems, for instance, are under cover, and tend to be quite dark. But if you wait till late afternoon on a sunny day, the sun will eventually be low enough to illuminate the cars.

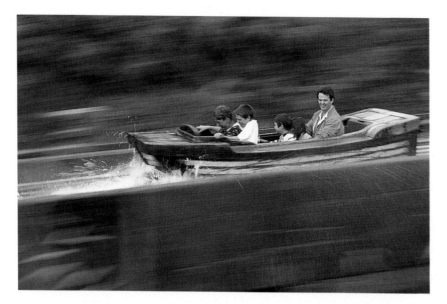

Panning action

If you have ever tried to photograph a fast-moving subject with a compact, you may have found that the subject blurs. This is because when you press the shutter release, the camera's shutter opens to allow light to reach the film.

Although it is open for only a short amount of time (say ¹⁄₁₂₅ sec) this is still long enough for a fast-moving subject to move through the frame, hence the blur.

On most SLRs you can set a faster shutter speed so that the subject remains sharp, but there may not be enough light for you to set a fast shutter and still maintain correct exposure.

With most compacts, you have no direct control over the shutter speed. In either case, if the subject is moving

past you, the solution may be to pan.

Frame the subject, then swing the top half of your body to follow it, keeping it at the same position in the frame throughout the

movement. Start as the subject moves towards you and take the picture as it passes you. The main subject should be sharp, but the background blurs, increasing the impression of speed.

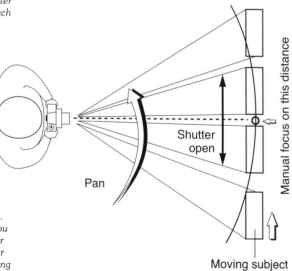

Shutter open

Pan

Manual focus on this distance

Moving subject

Sports and Games

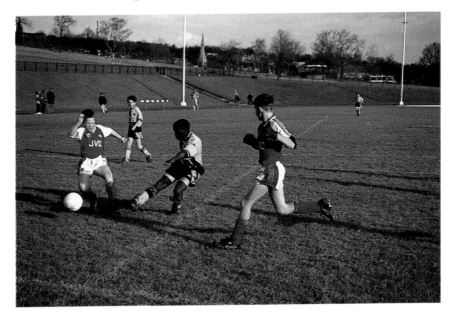

When you photograph your child playing a sport, you should aim to capture a well-timed shot of a dramatic piece of action. The first decision you have to make is where to stand.

With soccer or football you may be able to take a good photograph from anywhere around the field, but as most of the action centers around the goals, try standing to one side of the goal. When everyone runs towards you, you can guarantee shooting players from the front.

The benefit of SLRs

SLRs are better for sports photography than most basic compacts. First, they can be fitted with long telephoto

Focusing is easier when the subject is in the center of the frame. You will need to set a fast shutter speed to freeze the action, so unless the light is very bright, you will have to use a fast film.

lenses, so you can fill the frame with the subject, even when it is a long way from you. Second, they allow more accurate focusing. Autofocus cameras will sort out the focus for you, but with practice you should be able to handle manual focusing too.

In sports where your child is running around, you will get the best shots when you hold the camera to your eye and move it to keep your child in the center of the frame. While your right hand is ready to snap the classic picture, your left hand can

This quad biking shot was set up for the camera, but if you want natural shots of your children driving round the circuit, crouch down low to make the action look more dramatic. Use a telephoto lens and, if you are not using autofocus, prefocus on a particular point and shoot when the car reaches that point.

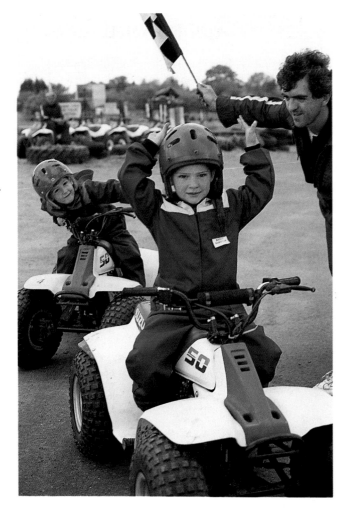

continually refocus the lens – with practice it gets easier.

Prefocusing your camera

A lot of sports involve the player running along a predetermined route. This includes most events at a school sports day, such as athletics, high jump and long jump. When shooting these, prefocus the lens on a set point and wait for your child to reach it. For instance, if you are shooting a hurdles race, stand near the finish and focus on one of the hurdles. When the child is in mid-air, take the shot.

For really fast action, you need to select a shutter speed of $\frac{1}{500}$ or even $\frac{1}{1000}$ sec to freeze the subject.

Capturing Action

Children don't run about only when engaged in sports – some children never seem to stop. Although your inclination may be to ask the children to stand still while you take a picture, set-up shots of subjects such as skateboarding and trampolining lack spontaneity – they're a lot better when the children are genuinely having fun.

Setting fast shutter speeds

As with conventional sports, your subject will blur if you don't select a fast shutter speed. On compact cameras, the shutter speed is selected by the camera, so you have to try and coax it into selecting a fast shutter.

The easiest way of doing this is to choose the brightest times to shoot. If you are shooting action in the summer, the light is so bright that the camera has to select a fast shutter speed to prevent the shot from being overexposed.

Alternatively, if you are standing close enough, you may be able to use daylight flash. Some compacts let you select 'flash on' manually – even in very bright conditions. Because flash is an incredibly strong light source, lasting a tiny fraction of a second, even fast subjects will be frozen.

To freeze the action when subjects are moving about, select a fast shutter speed. If you own a camera that doesn't allow you to set the shutter, try shooting in very bright conditions. The camera will automatically select a high shutter speed.

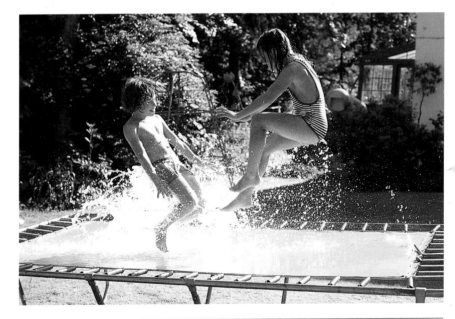

Predicting action

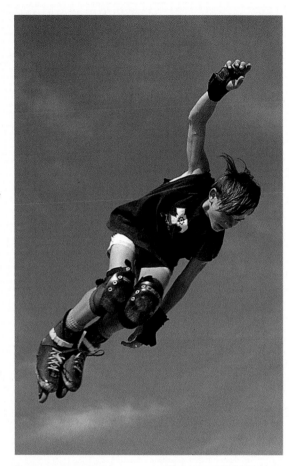

A lot of SLRs now offer programmed exposure modes. These have a dial that enables you to tell the camera what kind of subject you are shooting, so that its built-in microprocessor can determine the best aperture and shutter speed to select.

One of the most common program modes is for sport. When you select the sports program, the camera sets the fastest shutter speed the light level allows.

If there isn't enough light for you to set a fast enough shutter, you may get a sharp picture by choosing the right moment to shoot. Here, the child is almost stationary at the top of each jump, so the picture has been taken then.

Focusing on action

Focusing may represent a bigger problem, especially if the distance between you and the subject keeps changing.

Conventional autofocus systems on SLRs rely on focus lock. With this system, the camera focuses only when you press the shutter release halfway down. It then focuses on what is in the center of the frame.

If you don't want the subject in the center of the frame, you have to recompose the shot, while keeping the shutter release pressed.

Predictive autofocus

The problem with this kind of autofocus is that there is a small delay between the lens focusing and the photograph being taken.

If the distance between you and the subject changes in that small time, the subject will be out of focus.

Some autofocus SLRs combat this problem by offering an alternative focusing system called predictive autofocus.

When you select this program, the camera will continue to refocus the lens to keep whatever is in the center of the frame always sharp.

Focusing on a moving subject is made more difficult by the fact that there is a slight delay between pressing the shutter release and the shutter curtain opening.

This is because before it takes the picture, the camera has to set the right aperture and raise the SLR's internal mirror so that light can reach the film.

To combat this, predictive autofocus has another trick. If the subject is travelling towards you, apart from measuring the subject's distance from the camera, it also calculates the speed at which it is travelling. This enables it to predict where the subject will be at the exact moment the shutter opens – ensuring it is sharp.

At the Seaside

A hot day at the beach provides everything you need for memorable photographs – warm weather, attractive backgrounds, and children enjoying themselves. But remember when you set off for the seaside that cameras are sophisticated and delicate pieces of equipment, and need to be protected.

When you are not actually taking a photograph, keep your camera in a case. Some compacts have been designed with holiday photography in mind, and are sealed so that no sand or water can damage the lens or internal workings. But even with these you need to be very careful when opening the back to load the film – clean your hands and move away from sandy areas.

The sea itself can provide a clean, uncluttered background, enabling you to crop in on your child paddling in the shallows without including other distracting elements. Before you take the picture, scan the scene in the viewfinder to ensure you don't have half a person butting into the frame.

Beach games

Look out for interesting activities, such as beach games and sandcastle building. Normally, you should crouch down to photograph children from their own height, but if you spot a better view of the sandcastle by shooting down, then remain standing. Try a number of shooting positions before you take the photograph – or take a variety of views.

Polarizing filters

A useful beach accessory is a polarizing filter. This removes the reflections from some shiny surfaces, and can remove the dazzling glare of

Keeping warm

Although it's often better to crouch down and photograph children from their own height, here the elevated position means the shape of the sandcastle ring hasn't been lost. In addition, the low afternoon sun has bathed the whole scene in a warm golden glow.

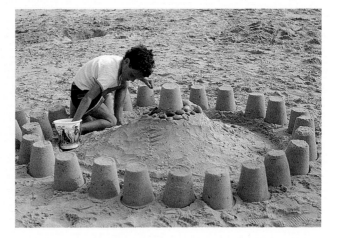

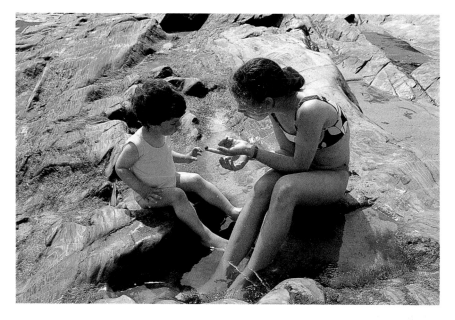

Above: Be on the watch for interesting activities, such as children investigating rock pools. This scene looks particularly attractive because of the co-ordination of the background colors with the greens of the two children's outfits.

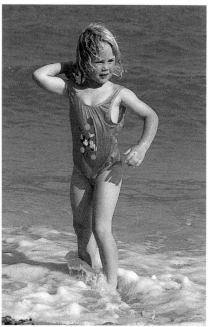

the sun on water – useful for both wide beach shots and for shots of children playing in rock pools.

A polarizing filter can also deepen blue skies and make white clouds appear more brilliant. If there are no clouds, but the sky is only pale blue, you can deepen the appearance of the sky by placing a graduated blue filter over the top half of the lens.

Right: The sea provides a colorful and uncluttered background for beach portraits. Even though the background in this scene is sharp, it is not distracting. Cropping in ensures there aren't other bathers creeping into the side of the frame.

On Vacation

When travelling abroad, the trick to a really stunning set of photographs is to combine people with places or local character. Look out for shots that will evoke strong memories.

If you are photographing members of your family in front of a famous monument, place the monument to the side of the frame. Use a wide-angle lens to ensure the background is at least relatively sharp.

Increasing depth of field

If you can set the aperture manually, selecting a small aperture will give you a wide depth of field. If you cannot

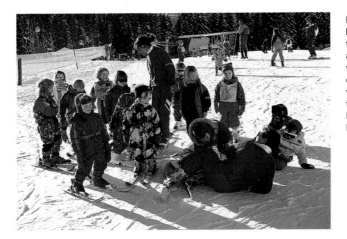

Despite the cold location, shooting in the early morning on a clear day provided warm lighting and crisp, clean snow. As with most group shots, the composition works best when all eyes are looking into the group.

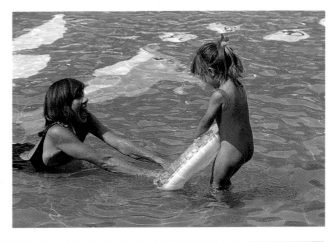

Although compact cameras don't give you the same degree of control as SLRs, they are generally easier to carry around. This makes them handy for grabbing those fun moments that are constantly cropping up on holiday.

Shooting in snow

Vacations are not only about hot weather and exotic locations. Skiing expeditions and even white Christmases represent the opposite end of the weather scale.

With a shroud of white over the landscape, background features become less defined, and sometimes a picture of the scene can look like a black and white photograph. Just after a heavy fall, the snow can take on a bluish cast.

If you would rather warm up the scene to make it look more appealing, add a pale orange warm-up filter to the front of the lens. Only do this when the snow looks particularly blue, however, as an orange warm-up filter can make a white scene look slightly muddy. Alternatively, use a pale pink filter.

With such a monochrome background, you can liven up the shots by dressing your children in bright, warm colors, such as red and orange.

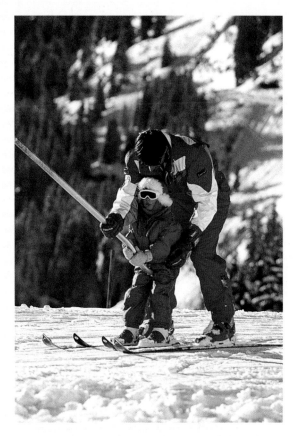

Exposure for snow

Achieving the correct exposure can be difficult in snow. The camera's built-in light meter may be fooled into reading the highly reflective snow as a bright light source. It will then underexpose the scene.

If you are able to set the exposure on your camera manually, use the camera's meter as a guide, then open the aperture slightly to overexpose the image.

Alternatively, move close to your child, so that their face is filling the frame, then take a correct light reading off their face.

Although few compacts offer complete manual control over exposure, many have a BLC (backlight compensation) button. When this is pressed, the aperture opens slightly.

alter it manually, try using fill-in flash, if your camera offers this facility. With flash, your camera will automatically set a smaller aperture, because of the boosted light level.

Whenever you use flash, the camera automatically selects a set shutter speed (known as the flash sync speed). Your camera may give you the option of selecting a slow flash sync speed – a combination of flash and a slow shutter. This option gives you a better chance of having a well-exposed background.

Look for off-beat shots –
although the child is about to
dance, this photo of her
nervously waiting her turn
also makes a good subject.

Chapter 3
INSIDE STORY

- Children's Parties
 - Dressing Up
 - Festivals and
 Celebrations
- Musical Instruments
 - Playing Games

- Ceremonies
 - Dancing
- School Plays
 - Story Time
 - Bath Time
- Time for Bed

When children are engaged in an energetic activity, frame them, then wait for good expressions and poses before you shoot.

Children's Parties

Children's parties are not only perfect for taking great pictures, but if your child has a party every birthday, they also provide a lively record of how the child changes from year to year.

Make sure you have several rolls of film – photo-opportunities are plentiful. Keep the camera close to you and look out for shots of the children enjoying themselves. They may play happily without any organization on your part, but you can help things along if you arrange party games.

A selection of lenses – or at least a zoom – is useful at a party. You need a wide-angle to photograph a group of children, and a telephoto to take some discreet close-ups.

Birthday parties

If it is a birthday party, a shot of the birthday child blowing out the candles is a must. Stand close, so the child and the cake fill the frame, but use a wide-angle lens to ensure both the cake and child are in focus.

Birthdays also mean presents, so have your camera ready when the presents are handed over and opened. Some of the most expressive shots of children occur when they are reacting to something – and a desirable present always gets a reaction.

Organized entertainment will not only liven up the party, but it will also give you a better chance of taking interesting pictures. Unless the room is exceptionally large, a wide-angle lens is a must.

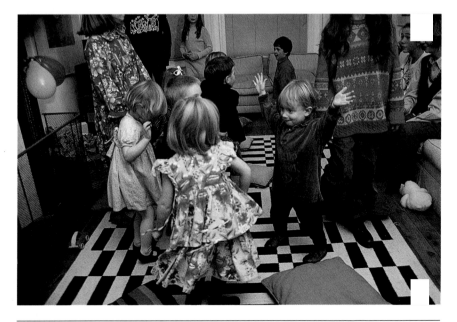

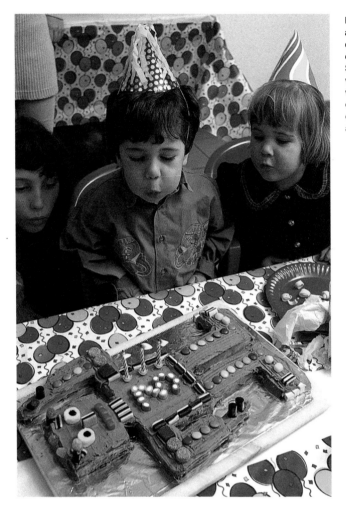

For birthday parties, a shot of the birthday child blowing out the candles is essential. Stand close and use a wide-angle lens and a wide depth of field to ensure that both the child and the cake are sharp.

Birthday props

You can never guarantee that good potential photographs will arise at an event, but you can give luck a shove by planning various games and activities beforehand. A magician, for instance, will keep the children both stationary and enthralled – but as they are likely to be seated on the floor, remember to crouch down so you can see their expressions fully.

A magician may also bring along props, such as balloons and a magic wand, and will often invite the children to take part in the tricks. You get the best shots when you frame a child, then wait for the right expression.

Even if there is no formal entertainer, a few balloons and party hats can make all your shots look more festive.

Dressing Up

One of the ways children learn is by copying their elders – either in their facial expressions, their turns of phrase, or the way they act. The most obvious method that children have of copying adults is to dress up – either in adults' clothes, or in children's outfits such as nurses' uniforms and cowboy hats. Many children enjoy dressing up – and you will get much better shots if they are involved in an activity which they enjoy.

Many special events include dressing up and face painting for children. As the child has to sit still for a while, you can take your time composing the shot, framing them so their face fills the frame. When their face is so large in the frame, stand back a little and use a telephoto lens – using a wide-angle lens often creates an unattractive distortion.

Exposure bracketing

Before you take a photograph, the camera measures the light level in the scene. It then selects a shutter speed and aperture that will allow just the right amount of light to reach the film.

When there is a high degree of contrast in the scene – such as between bright and shadow areas, the camera might make the wrong decision. It might, for instance, expose for a light part of the frame, when you want it to expose for a darker area.

With print film, small exposure inaccuracies can be corrected in the printing process. With slide film, however, correct exposure is critical.

To make sure they end up with the perfect exposure, some photographers take a number of shots of a high-contrast scene – some slightly underexposed and some overexposed. This is known as bracketing.

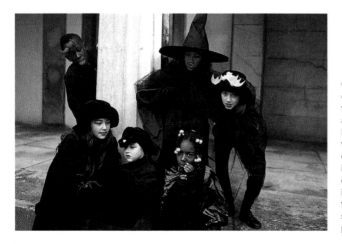

Children are usually eager to dress up for fancy dress parties and events such as Halloween. When there are a lot of children all dressed in a similar way, encourage them to act in character, rather than asking them to stand in a line for their photographs.

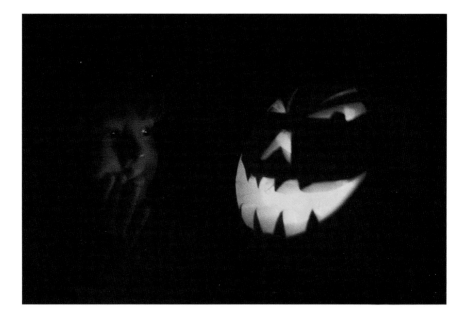

Festivals and Celebrations

Every culture has festivals and celebrations at set times during the year. Sometimes these are formal affairs with very set routines, while others are simply a good excuse for everybody to have a fun time.

Festivals such as Christmas are particularly exciting for children. Decorating the Christmas tree, writing to Santa and awakening on Christmas morning have a magic about them that is special to childhood.

As these events often follow a set routine, it is easy to work out when the best photo-opportunities are going to arise. Aim to capture the thrill and excitement experienced by the children in your pictures.

Candlelight

Candles play an important part in many festivals. As a light source, they are far more atmospheric than daylight or most electric lights. However, they provide very little illumination, making it difficult to take photographs of candle-lit scenes without flash. Flash, of course, kills the atmosphere generated by candles.

For successful candle-lit pictures, you will need to set a very slow shutter speed. If you have an automatic camera, it will select a slow shutter for you. Either place the camera on a tripod or lean against a solid object so the camera is steady. Tell your subjects to stand completely still to minimize the chance of blur.

Left: Although an automatic camera would have wanted to use flash here, the effect would have been lost completely if flash had been used. The camera was placed on a tripod and the child was asked to remain perfectly still during exposure.

An external tungsten light (*right*) gives more light overall, but loses atmosphere. With the boy's face lit from below by the light in the pumpkin (*far right*), the spooky feel of the scene is maintained.

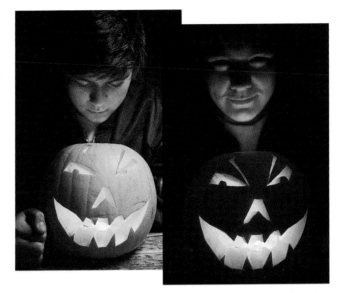

Going for grain

Different types of film are more sensitive to light than others. This sensitivity is known as the film's speed – the more sensitive a film is to light, the faster it is said to be.

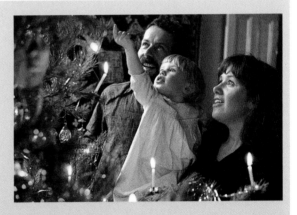

Film speed is expressed as an ISO (International Standards Organization) number – such as ISO 100 or ISO 400. The higher the number, the faster the film – for instance, ISO 400 film is twice as light sensitive as ISO 200 film and four times faster than ISO 100.

In dim conditions, a slower film, such as ISO 100, might require you to set a slow shutter speed to obtain the correct exposure, which could give rise to camera shake. By using a more sensitive film, such as

KODAK GOLD Ultra 400 Film, you will be able to select a fast enough shutter to eliminate the risk of blur.

Fast films don't reproduce to the same quality as slower films. The faster the film, the grainier and less detailed the image. But grainy shots

such as this can have an atmospheric and sometimes nostalgic feel to them.

Very basic compacts can often only recognize ISO 100 and ISO 400 films – they assume ISO 200 film is ISO 100 and ISO 1000 film is ISO 400.

Musical Instruments

When you look back at old photographs of your children in years to come, the shots that will stand out are those that stir the greatest memories. That's why you should aim to take photographs of your child engaged in the activities that they enjoy most.

Many children have an interest in music – some even become proficient at playing an instrument. An ideal time to photograph your child is when

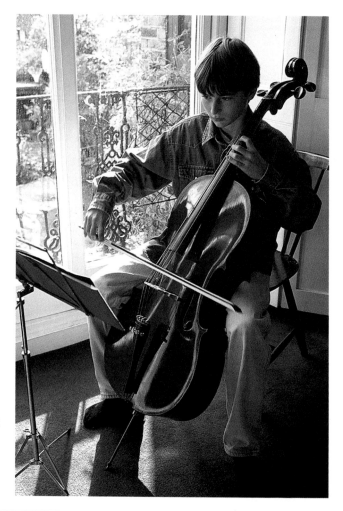

The camera was placed on a tripod for this shot and framed so that even when the boy moved his arm, neither he nor the bow burst out of the frame. He then played very slowly until he reached this position, which looked the most natural. He was asked to hold the position while the photograph was taken.

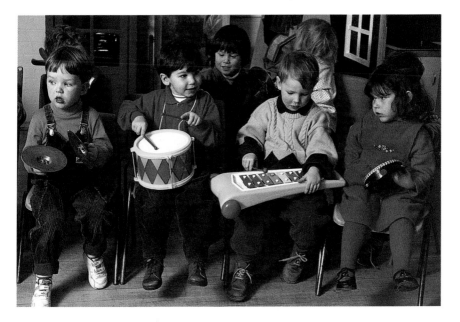

they are playing – you have time to compose the shot exactly as you want, and the child looks natural, because they are engaged in an activity that requires concentration.

When there is a line of children engaged in an activity, such as the aspiring musicians here, crop in so that there are no children half in and half out of the frame. Take several shots and discard any where the expressions aren't quite right.

Choosing the position
Ask your child to move slowly – effectively playing in slow motion. This not only restricts the chance of parts of the subject blurring, it also allows you time to study their hand and body movements.

With many instruments, there are times when the instrument or the subject's hand passes in front of their face – or when they turn to face away from the camera. Watch for a while before you take the photograph to determine which position looks best.

Although you are likely to get a more natural shot if you take the picture while the child is playing, you may find the photograph easier to shoot if the child is holding a fixed pose. Make sure the position looks authentic by asking the child to play slowly and stopping them at the pose that looks best.

If you are photographing small children, who may have no musical ability but who just like to make a noise, you don't need to set up the shot to make it look as if they are skilled musicians – the attraction of the subject is that you will be taking photographs of infants having a really good time.

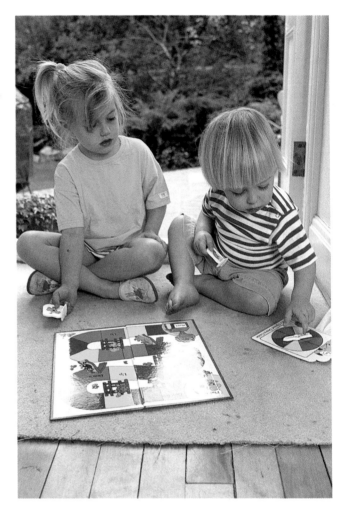

A wide-angle lens has been used here to ensure maximum depth of field in the scene. This ensures that the game is sharp as well as the children. Wait for interesting action, such as the boy here spinning a colorful dial.

Playing Games

If your children are very active, taking informal photographs of them sitting still may be difficult unless they are occupied with an activity that keeps them in one place. They may become stationary while watching TV or playing computer games, but they are unlikely to sport the interesting expressions that make for good photographs.

Board games offer the ideal solution. They involve active

All kinds of things can keep children occupied, other than toys and games, as this boy shows. Probably only he has a clear idea of what he wants to achieve, but what makes the photograph work so well is his intense concentration.

participation by the players – and, as many games are brightly colored, they also make appealing props.

Choose the best position to shoot from – if there is a natural gap between two of the players that allows you to take a photograph of the whole group, stand back slightly and use a wide-angle lens and narrow aperture to ensure a wide depth of field.

You don't have to include the game in the shot – if you are shooting a close-up of one person, look out for them engaged in activities requiring intense concentration – like shaking the dice for a really good throw.

Comparative heights

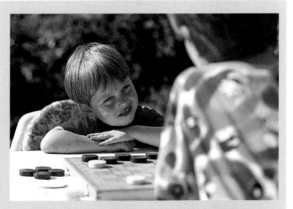

The main subject of this shot is the child in red and the perplexed look on his face. However, if we had simply cropped in close on him, we would not have seen what caused his look – the fact that he is playing a game which his expression tells us he is losing.

To reinforce this idea, his opponent appears to be much larger than he is. This is a trick caused by standing very close to the boy in blue and using a wide-angle lens – the boy in red is three times as far from the camera as his opponent, so he inevitably looks a lot smaller by comparison. Crouching down also makes the boy in blue appear bigger.

If a telephoto lens had been used and the shot had been taken from further back, the relative distances from the camera of the two boys would have been much less – the two children would then have appeared to be similar in size in the frame.

Ceremonies

Ceremonies such as christenings, weddings and bar mitzvahs are essentially set pieces. Unless you are directly involved, most of the work is done for you – all you have to do is turn up and spot the good pictures.

Often the people arranging the ceremony will organize a professional photographer to take set photographs. This means you should concentrate on more off-beat pictures, such as candid shots of children when they don't realize you're shooting them and close-ups of people relaxing.

Prepare your shot
If a child is facing away from you, frame the shot and work out how you are going to take it before you attract his attention. This way you will be ready to shoot, and there won't be time for the child to get self-conscious.

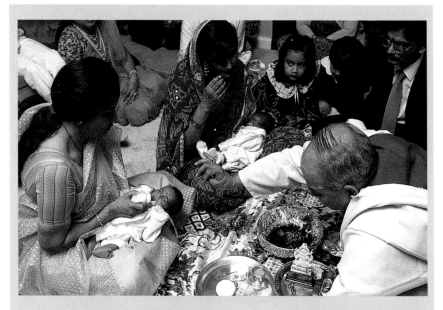

Bounced flash

If you have to take a photograph during a ceremony, the usual low light means you should probably use flash. If you use fast film instead, the aperture may still have to be wide open, giving a very narrow depth of field.

The advantage of an SLR in these circumstances is that you can use a powerful add-on flashgun, rather than the less powerful units built into most compacts and some SLRs. Flashguns with movable flash heads can be aimed away from the group – either at a white wall or ceiling or at a reflector.

When you bounce light off a ceiling and down on to the group, the effect is far less harsh than you would get if you used direct flash.

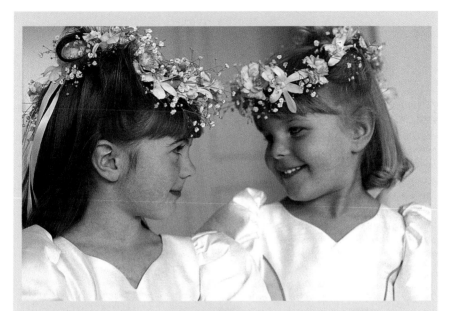

Soft lighting

The modelling on a child's faced caused by the contrast between light areas and shadow can look dramatic, while at the same time it can reinforce the shape and detail of the subject's features.

In some situations, flat and even lighting can be more appropriate. This is particularly the case when you want to bring out the sweet, gentle nature of the subject, as you would here with the two bridesmaids.

A strong, directional light source, such as the sun or flash, can look too harsh, but the light on an overcast day is ideal. When inside, stand with the window behind you. If the light is still too harsh, because the sun is shining directly in through the window, soften it by placing a net curtain over the window.

Many churches are dimly lit, so you have no option but to use direct flash. The ceilings are unlikely to be low or white so you cannot bounce the flash. With some flashguns, you may be able to soften the light by placing a piece of tracing paper over it or bouncing the light off a piece of white card. Remember, though, that this will reduce the amount of light.

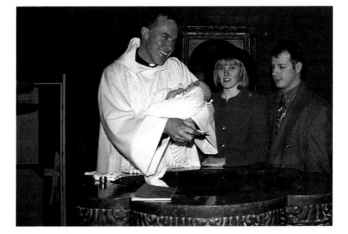

Dancing

Dancing and ballet classes involve a lot of action and movement, but unlike most sporting subjects, the movements are coordinated and predictable. This gives you time to study the action and work out the best shooting position and composition.

Ballet alternates between swift movement and momentary fixed poses. If you can anticipate the moments when the dancers hold a position, you will be able to use a relatively slow shutter speed – ⅟₆₀ sec or even ⅓₀ sec. If you shoot during one of the movement phases, you will have to set a much faster shutter speed.

Right: In ballet, the dancers often wear costumes, so it is as much related to dressing up as it is to movement, and you may be able to find quieter moments of inactivity that also make good pictures. These provide an interesting contrast.

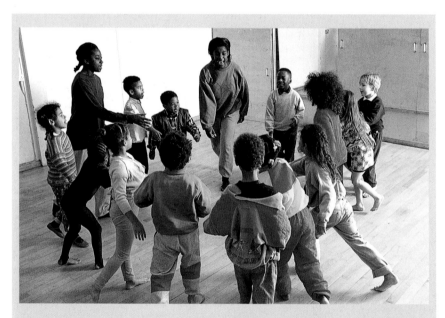

Dance energy

With some performance dances and ballet, the children may hold various interesting poses, but with other dances and aerobic exercises, the dancers are constantly moving.

Wait until the children are used to you being there with the camera before you shoot, then look out for moments when they really look as if they are moving energetically. The most interesting compositions involving groups of people

dancing are when they are all in the same pose. Even if people are simply dancing to a disco record, you may be able to find points in songs where everybody is throwing their arms in the air or clapping – choose these moments to shoot.

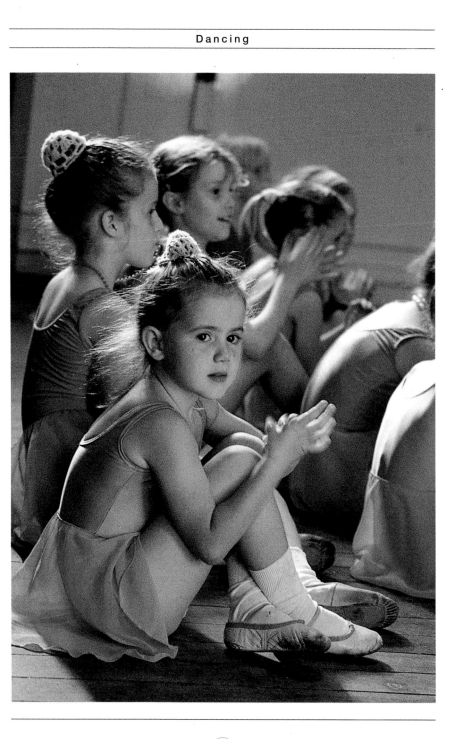

School Plays

School plays can provide some of the most memorable childhood shots, yet they present a major challenge for a photographer. The subjects are often some distance away from you, lighting is rarely ideal, and you have to take your pictures without disturbing anyone in the audience or on stage.

Preparation

If you are really serious about shooting on-stage shots, you should seek permission to go along to a dress rehearsal. When there is no audience, you have the freedom to move about without constantly walking in front of people trying to watch the play.

Find out beforehand where your own child stands when they appear on stage, then head for a seat that gives you a clear line of sight. This isn't always on the front row – in fact, if the stage is fairly high, you are better to sit further back, otherwise you risk looking up at too great an angle.

Shooting during a performance

The best seats are generally next to the aisle. They usually offer fairly clear lines of sight, and they enable you to move out into the aisle without

Sometimes, stages can look very two-dimensional, so try to shoot when there are subjects at different depths in the frame. Here the shot looks good because the different head heights provides a gentle curve through the frame, rather than the more conventional horizontal line.

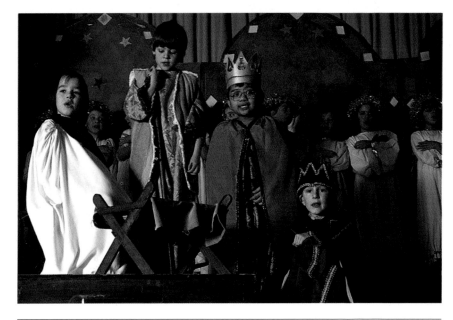

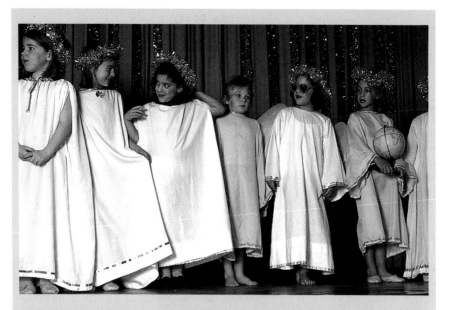

Off-camera flash

One of the biggest problems to overcome when shooting school plays is the lighting. If the stage is lit by spotlights, check whether they are tungsten halogen – in which case you should use tungsten film – or daylight balanced, when you can use normal daylight film. Either way, you will probably need a fast film to enable you to set a fast enough shutter to avoid camera shake.

Although some on-camera flashguns may be able to illuminate your subject, most built-in flashes are too weak to light up the whole stage. If you are taking pictures at a rehearsal, and so can work without disturbing people, your best bet is a flash gun positioned close to the stage.

Here, the flash has been placed to the left of the stage, so the children on the left are better illuminated. For a more even spread of light, bounce the flash off a white wall or piece of card.

disturbing the people around you. If the scenery is impressive, take some wide-angle shots to include the whole stage. Even though your child may be small in the frame, wide shots such as this can bring back a flood of memories in years to come.

Telephoto lenses

Your distance from the stage makes a telephoto lens essential for close-ups. If you are shooting during a performance, you will only be able to steady the camera on a tripod if you set it up at the back of the hall, but again, ask permission first.

Find out from your child if they participate in any important scenes and when these take place, so you can be ready for them. A shot of your child talking or involved in an action is far more interesting than a shot where they are standing still.

A telephoto zoom lens is very useful. As you can't move about, you will need to vary the focal length of your lens to change the crop, without having to swap lenses.

Story Time

Most young children like to be read a story, and story time provides a first-class opportunity to photograph a child and parent together. When a story is being read to them, most children like to see the book for themselves and look at the pictures. This means the composition is very tight, as reader and listener will be sitting very close to each other.

Tungsten film

If the lights in the room are particularly bright – and you are using a lens with a fairly wide maximum aperture – you may be able to shoot without using flash. However, as indoor lights are a lot more yellow than natural daylight, you will need to use special tungsten-balanced film.

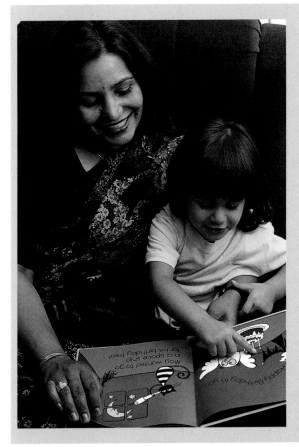

Hold the pose

Apart from providing an interesting situation to photograph, children's books can also make colorful props in themselves. If you shoot from slightly above, you can emphasize the cosiness of the scene and also show the pages of the book. Choose a page that is colorful and features large figures.

If you are using available light rather than flash, tell your subjects to sit still so that they don't blur because of the slow shutter speed. Remember to use the correct film to match the color of the dominant light source.

A natural pose

Make sure the children look as if they are engrossed in the story by asking them to point and look at one of the pictures. Ask them not to look at the camera, as this will make it obvious that the shot is set up and not taken as they are naturally enjoying themselves.

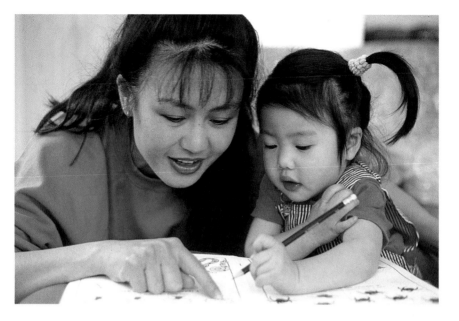

Tungsten film is far more sensitive to blue light than outdoor film, so even under yellow and orange lights, the colors look fairly natural. Rather than being ISO 100, 200 and 400, tungsten films rise in multiples of 160 – such as ISO 320 and ISO 640.

If you are shooting under fluorescent lights, use daylight film, but add a magenta filter to the lens.

Camera shake

If your subjects are very still, you may be able to get away with a slow shutter speed. Your shots can still suffer from camera shake, however, if you are handholding the camera – you may not be able to hold it for as slow as $\frac{1}{15}$ or $\frac{1}{8}$ second without your hands shaking slightly.

The magnification of the image caused by using a telephoto lens

As well as containing stories, some children's books have pictures that can be colored in. Take a picture while the child is busy coloring. If she sits by a window, she will be able to see better for reading and drawing, and there should be enough light for you to take a photograph.

means that camera shake is far more likely when you use a telephoto than when you use a wide-angle.

There is a general rule of thumb that tells you the slowest shutter speed it is safe to use when using a particular lens.

If you are using a 500mm lens, you should always set a shutter speed of $\frac{1}{500}$ second or faster. If you are using a 50mm lens, you should use a shutter speed greater than $\frac{1}{50}$ second. With a wide-angle lens, you should be safe with $\frac{1}{30}$ second. Alternatively, use a tripod to keep the camera still.

Bath Time

Choosing your shooting position is all-important when you are photographing bath time. Not only do you have to be careful that an overzealous son or daughter doesn't decide to splash the camera, but most bathrooms are either heavily mirrored, or are decorated with very reflective tiles.

Check the viewfinder thoroughly to make sure your reflection isn't in the photograph. Even when tiles get wet

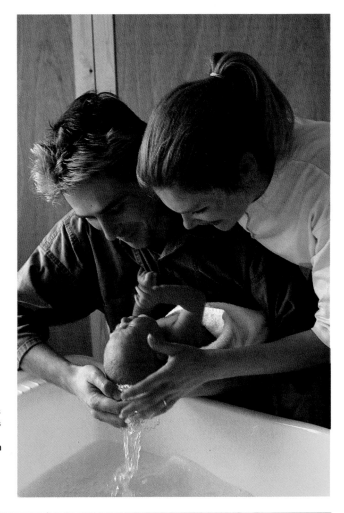

To avoid flash problems here, the sun streaming in through a window has been used to light this shot. Some of the window light has been reflected back from the bathtub, giving a warm, yellow glow to the picture.

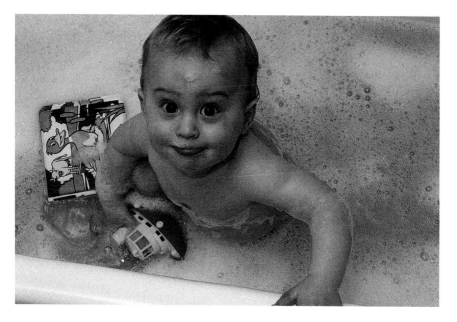

through condensation, they will not reflect your image like a mirror will, but they may show your silhouette – and they will certainly reflect direct flash, which can ruin the image.

The easiest way of avoiding a bright 'hotspot' where the flash reflects off the back wall is to crop in tightly on your subject, so that very little

When children are playing in the bath, try to capture in their expressions the fun they are having. Bath toys add interest to the shot. Shooting down prevents you catching your own reflection in the tiles.

background is included. Another way, if you have an appropriate flashgun, is to bounce the flash off the ceiling.

Crop in close

If you are photographing a baby's bath time, include your partner in the shot. If the children are a little older, it may be better to photograph them simply playing. Find the most appropriate props, such as plastic ducks, and include them in the shot.

If two or more children are playing in the bathtub, you may have to wait with the camera to your eye before you see a shot where all the children have interesting expressions.

Weatherproof housings

If you are worried about taking your camera into the bathroom in case it gets splashed or damp with condensation, why not spend a little bit of money and buy a weatherproof housing for your camera? The most basic housings are relatively inexpensive and consist of a plastic bag which fits round the camera and seals to make it water-tight. Housings can be bought from specialist camera stores, and some manufacturers produce dedicated housings for their own cameras.

Time for Bed

If you want a photograph of your children that shows them looking sweet and angelic, there is no better time than when they are tucked up in bed. As babies can sleep at any time, you can shoot during the day, using natural window light. With older children, who may only sleep at night, you have to add artificial lighting, such as flash.

Pushing film

If you want to shoot using natural light, but the light level is low, you can normally use a faster film, which is more sensitive to light. However, if the only film you have isn't fast enough, you can increase its sensitivity by uprating or 'pushing' it.

When you uprate a film, you treat it as if it is a faster film than it is. So for instance, you can load your camera with ISO 200 film and uprate it by one stop. In this case, you set the film speed dial to ISO 400 and set the shutter speed and aperture as if you were using ISO 400 film.

When you take the film to be processed, you tell the processor that you have pushed the film by one stop. What you have effectively done is underexposed every shot on the film by one stop, so the processor increases

Not all bedtime shots need to show your son or daughter asleep. Putting your child to bed can be one of the relaxing pleasures of the day. In this case, include your partner sharing quality time with your child.

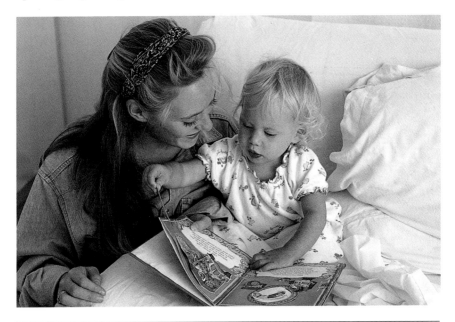

the development time, which would normally overexpose the image slightly.

The result is a roll of properly exposed photographs, but the down side is that pushed film tends to become very grainy. The contrast on the shots is also increased, so that overall quality is reduced.

Suitable films to push

The quality difference between a normally exposed slow film and a pushed slow film is often quite marked. However, faster films, such as ISO 1000 and ISO 1600, tend to react better to being pushed. Some fast films can be pushed by three or four stops and still give acceptable – if grainy – results.

Exposure errors on the negative of a color print film can often be corrected by printing, so pushing the film can be unnecessary. This is not the case with transparency film, where uprating the film speed is more commonplace.

The teddy bear headboard in this picture complements the scene of the infant asleep. Think about the shot before you take it, and crop in on the important parts.

Cute factor

If you shoot a child from his or her own head height, it is easier for people looking at the picture to associate more with the child than when they are looking up to or down on them.

Looking down on babies, however, can emphasize their vulnerability and thereby their 'cuteness' factor.

Use props to liven up your shots by adding color and interest to a scene. Props also occupy your child so they adopt a more natural pose.

Chapter 4
IMPROVING YOUR SKILL

- Portrait or Landscape?
- Composing the Picture
 - Backgrounds
 - Props and Set-up Shots
- Natural Frames
- Adding Depth
- Narrow Focus
- Wide Focus
- Focal Length
- Camera Height
- Unusual Angles
- Full-length Shots
- Close-up Portraits
- Natural Portraits
- Formal Portraits

Look for the best moment to shoot during any movement routine – frame the child, then shoot when you see the pose you want.

Unusual poses can make interesting photographs too – don't just look for pictures of children smiling at the camera.

Portrait or Landscape?

Whatever the subject of your shot, a knowledge of the basic skills of photography will help you to take better pictures – and without your having to use lots of film to get just a couple of good shots.

The most basic decision you have to make when you use a 35mm compact or SLR is which way round you want to hold the camera. Shots that are wider than they are tall are called landscape format; shots that are taller

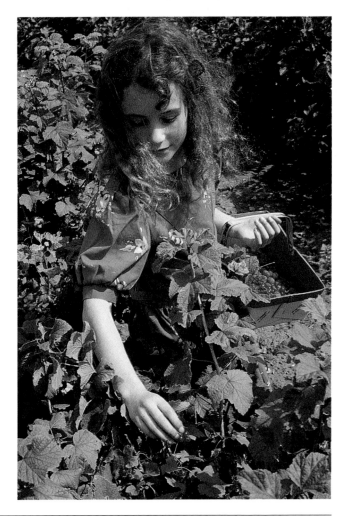

A portrait format has been chosen for this shot for two reasons. First, a lot of the girl has been included, as she is naturally portrait-shaped, but equally important is that she is facing forward. This means the interesting part of her environment is in front of her, so the scene to either side is less relevant.

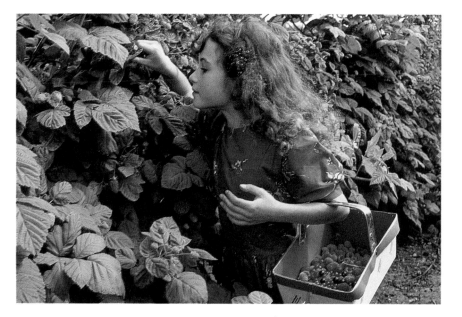

than they are wide are known as portrait format.

The obvious guideline is to use portrait format for tall subjects and landscape for those that are wider than they are tall. However, things aren't as straightforward as that. A person may be taller than they are wide, but a head-and-shoulders portrait may be as wide as it is tall.

Rotating the camera

There may also be other subjects you want to include in the frame. For instance, if you want to photograph your child full length at one side of the frame with a panoramic landscape or famous building to the side, then landscape format will be more appropriate. Before you press the shutter release, scan the area around the subject to determine exactly how

Here, the child is facing to the side and the important part of her surroundings is to the left of the frame. By selecting a landscape format, we can show both her and the fruit she is picking. The landscape format also provides looking room in the direction the girl is facing.

much of the scene you want to include. If you have time, rotate the camera between portrait and landscape formats to see which looks best.

Portrait shots tend to look more formal than landscape shots. They also allow you to crop out unwanted background detail.

If the child is looking forward, portrait is often more appropriate, whereas if the child is looking to the side, a landscape format will allow you to show some of the scene to one side, so that they don't appear to be staring out of the frame.

Composing the Picture

When you learn a new technique, you may have to think whether it is relevant to the picture you are taking. Eventually, however, the skill will become second nature, and even without thinking you will take better photographs.

One of the first decisions you have to make is how much of the frame your main subject should occupy. You may want to include all of the child from head to foot, but more often you will want to move closer, so that you can see their facial expressions.

Cut-off points

When you don't include the whole subject, you have to think carefully about where you cut them off in the frame. If you cut them off at the ankles, missing out their feet, the shot looks poorly composed.

Subject placement

Some shots look neat and well composed, whereas some look untidy – often it is difficult to decide why some pictures look good and others don't. There are a number of basic rules of composition that crop up in different parts of this book.

● *Headroom*
Unless you want to show a tall subject behind your child, place their head near the top of the frame. If there is too much headroom above them, they look as if they are sinking off the bottom of the picture.

● *Off-center subjects*
Although it is common to place your subject in the center of the frame, if they are to one side of the center, the shot often looks more interesting.

● *Rule of thirds*
The composition looks particularly attractive if subjects are placed a third of the way from the edge of the frame (see page13).

● *Looking room*
When the subject is facing left or right, place them so there is a lot of space in front of them and very little redundant space behind them.

In this shot we are showing the girl playing with building blocks in her garden. If we had cropped in any closer, we would have missed some of the subject. However, as the background is unimportant, we did not need to come out any further.

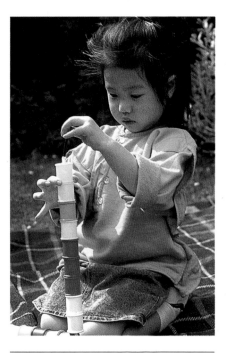

Also avoid the knees, waist (if they are wearing a belt) and the neck. Shots look more attractively composed if you cut the child off just above the knees, above or below the waist and around the armpits.

Whether you opt for a full-length shot or a head and shoulders composition should depend on what the subject is doing or wearing and whether the background is relevant to the subject or not. The three different compositions below reflect the activities the child is engaged in.

Automatic composition

Some zoom compacts incorporate a feature known as auto-composition. When you engage this function, you select whether you want a full-length shot, a medium shot or a head-and-shoulders shot. The camera then measures the distance between you and the subject and automatically zooms the lens to the appropriate focal length.

Some even work continuously, zooming out from telephoto to wide-angle as the subject moves towards you. Remember, however, that the camera may have been programmed to compose for adults. If you are photographing a small child, the camera may still select a slightly wide crop.

Here, the girl is having great difficulty with fastening one of the buttons on her top. If we had opted for a full-length portrait, to show her entire body, her face would have been too small for people looking at the picture to see her look of intense concentration.

As the girl has the apple up to her face here, this is the subject we have decided to concentrate on. We have included some of her arms and shoulders, but anything else in the shot would have been irrelevant, so a close crop was chosen.

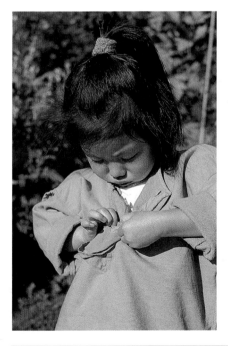 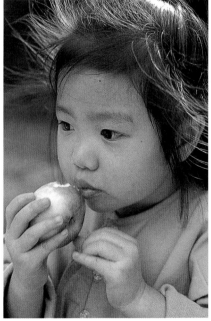

Backgrounds

When you compose a shot of a child or children, you should also scan the background before pressing the shutter release. A distracting background can draw attention away from the main subject and is likely to ruin the shot.

Simple, uncluttered backgrounds often look best. If there are too many elements in the frame, the shot may look confusing. Avoid backdrops that compete with the subject for attention. Crop in closer on the child to avoid a cluttered shot.

If the light is fairly even, so that it doesn't matter which direction you shoot from, walk round the subject until you find the angle that provides the most attractive background.

Here, the composition has been kept clean by limiting the scene to only two colors. Although a sofa is a potentially distracting subject, it blends in with the walls and floor to create an uncluttered setting.

Complementary backgrounds
Sometimes the setting can play an important role in the photograph. In the shot on the opposite page of the girl holding the white cat, both foreground and background complement the main subject. Not only is the setting attractive, but also the orange and white flowers in the foreground match the dominant colors in the subject.

When you are out and about with your family, always be on the lookout for attractive scenery to act as a

backdrop. If you use a wide-angle lens and stop the aperture down as far as the light level allows, you will be able to photograph your child or family against a picturesque background, and still keep everything in the shot fairly sharp.

Distracting backgrounds

When we view a scene, each of our two eyes sees a slightly different image, and this helps us to judge the distance of the various objects in the location. When we look at a photograph, however, we see a two-dimensional image, and this makes distance a lot more difficult to judge.

This can give rise to situations where a tree or lamppost – or even another child's head – appears to be growing out of the top of your subject's head. Although our brains can rationalize the scene, so we know that the tree isn't actually growing out of their head, the composition still looks ugly, and should be avoided.

You can eliminate a distracting background completely by using flash. This lights up the subject while rendering the background dark.

The background is an essential part of this photograph. The location has been specially chosen for its attractiveness and because the white and orange flowers match the colors in the subject.

Flash will illuminate close subjects, but is not powerful enough to light distant subjects. This means that the camera can render the background dark while keeping the foreground exposed correctly.

Props and Set-up Shots

The simplest way of livening up a portrait is to include another element that adds interest to the picture. This can be anything from a simple prop, such as a toy, to a complex set-up shot – for instance, showing two views of your child by asking them to look into a mirror.

The simplest set-up shots involve simply giving your child something to occupy them to give you time to compose the shot.

Alternatively, you can ask your child to pose in a particular way. This is easier with groups of children, as groups tend to be less self-conscious.

Right: Sometimes, set-up shots can look more natural than grab shots. It all depends on thinking about what you want before you shoot.

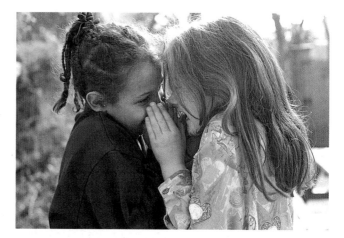

Below: A classic set-up shot. Set-up shots are easier with groups of children, as a single child may be self-conscious.

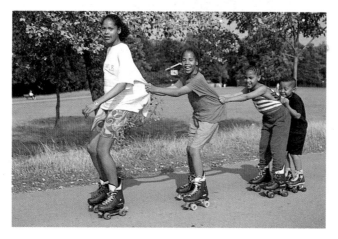

Right: A formal portrait, with the child smiling for the camera, but the balloons add color and a sense of fun to the photograph. Try to choose props that not only occupy the child, but also contribute to the attractiveness of the image.

Natural Frames

A good technique for drawing attention to the important subject in a shot is to have your child stand inside a frame. Obvious frames include windows and doorways, but with a bit of imagination, you may be able to find others in a location.

Apart from drawing attention to the subject it surrounds, a frame can add impact to the subject too. In the shot on the opposite page, a decorative natural arch of berry-laden branches has been used to frame the child.

Not only is the archway appealing in itself, but it also emphasizes the child within it. The result is a much stronger composition than you would achieve by simply placing the subject against a plain background.

When you are photographing a child inside a rigid frame, such as a door or window, make sure the edges of the frame are parallel with the edges of your camera's viewfinder. If the frames are slightly crooked, the shot will look like a mistake. Ideally, place

Time of year

Framing with foliage is more effective at some times of year than at others. Some trees produce spectacular blossoms during the spring, while others have leaves that turn deep red in the autumn before they fall. Find out when the trees in your area are at their most colorful, and use them as frames or backgrounds at these times of year.

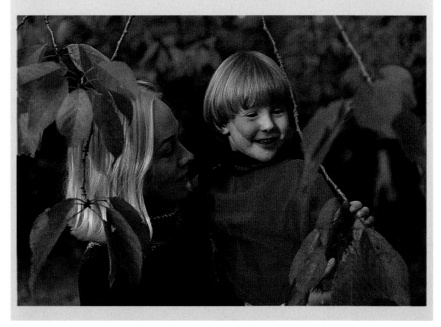

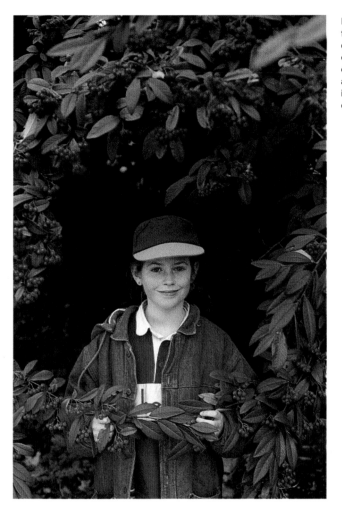

Look out for natural frames, such as this decorative arch. The composition looks clean and uncluttered, and the frame increases the impact of the shot.

the camera on a tripod to ensure accurate composition.

When you use a frame, you can effectively change the shape of the photograph. Mirrors make popular frames, and a round or oval mirror will convert the picture area to its own shape. If there is interesting subject matter around the mirror, the frame will divide the photograph into two distinct picture areas. Be careful when photographing subjects in a mirror not to include your own reflection.

Frames don't have to be obvious. You can frame a subject subtly by including foliage at the top of the frame or a tree and branch at the side and top of the photograph.

Adding Depth

Your eyes are separated by a few centimetres, so each sees every object in a scene from a slightly different viewpoint. By measuring the difference between the images from each eye, and comparing them against what we know about the size of each object, the brain can determine distances fairly accurately.

A photograph is merely a flat piece of paper – so our eyes cannot perceive depth naturally. Yet photographs that have a three-dimensional feel to them are often more effective than those that look flat, so it is a good idea to add the illusion of depth to a photograph.

The illusion of depth is known as presence, and it can be achieved in a number of ways. The easiest when photographing children is to line a number of them up and photograph them at an angle so they make a diagonal line in the frame, like in the shot of the ballet dancers below.

We can guess that the children are all of similar height, yet they grow smaller in the frame as our eyes move to the left. This gives us a much stronger feeling of depth in the image than if they were all the same distance from the camera.

Although photographs are naturally two-dimensional, this one is given a feeling of depth by the shooting angle. As the children are the same size, the smaller ones are obviously further away than the larger. The illusion of depth is called presence.

Emphasizing depth

You can emphasize this effect by using a wide-angle lens. Wide-angle lenses stretch perspective, so that the closest child looks a lot larger in the frame than the second closest. A wide-angle also provides you with a wider depth of field than a telephoto – an important point to remember if you want every child to be fairly sharp.

You can help to ensure the scene is in focus throughout by shooting in bright light, as this will allow you (or the camera if it has auto-exposure) to select a narrow aperture.

Notice how an imaginary line joining the tops of the children's heads runs diagonally through the frame, whereas in reality it is horizontal – because the children are all of similar heights. Most diagonal lines in photographs are in fact horizontal or vertical lines, but by changing our shooting angle we can turn them into diagonals, which help draw our eyes into the frame.

Lead-in lines

When we see two straight lines that we know are parallel, shooting them so they appear to converge can add a strong impression of depth to your photographs. In the shot here, the child is standing in the middle of a path. Although he is small in the frame, the converging lines of the path lead our eyes directly to him.

We know the sides of the path are parallel, so the fact that they converge gives a strong feeling of depth in the frame. The wider the angle of the lens you use, the steeper the diagonal lines become – increasing the impression of depth.

If you were to move to the side of the path, so that you were shooting across it, the edges of the path would become parallel again, and the apparent depth would be lost.

The effect is more obvious when a wide-angle lens is used, as the degree of convergence is greater.

Narrow Focus

Our eye is automatically drawn to the portion of a photograph that is sharp. This means that even if your child is standing against a very cluttered background, you can make them stand out from their surroundings by throwing the background out of focus.

There are a number of ways of limiting the depth of field to pick your subject out from the background. First, you can select a longer lens. Telephoto lenses have restricted depth of field, with longer lenses offering very tight bands of focus.

Aperture is also important. Select a very wide aperture, and depth of field is severely reduced. Finally, the closer the subject is to the camera, the narrower the depth of field you get.

Fill-in flash

In backlit situations, many camera manuals recommend using fill-in flash – a low-powered burst of flash that brightens up the subject without reducing the background to total darkness. With the increased light on the subject, the camera can afford to set a narrower aperture. When you want to lose detail in the back-ground, it is better to open the aperture and avoid flash. In the flash photo (left), the sharp background detracts from the subject. In the natural light photo (right) the child stands out much more clearly.

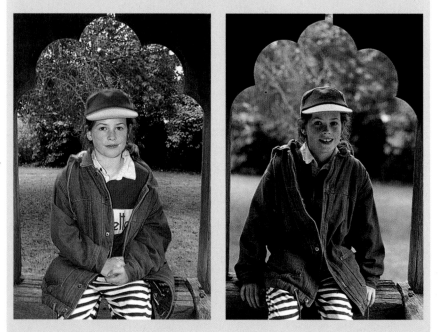

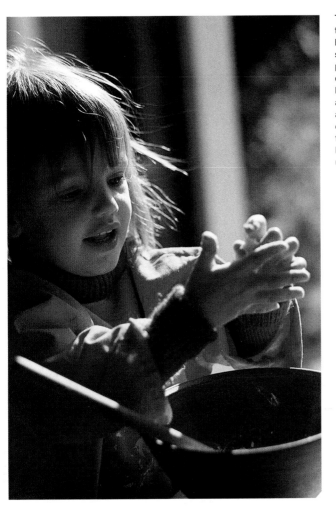

The strong lines of the doorway in the background of this shot would have provided a strong distraction had they been sharp. By setting a very wide aperture and throwing them completely out of focus, they simply become part of an undefined backdrop.

Film speed and compacts

If you have a compact camera that doesn't allow you to select the aperture manually – or offers no program modes for limiting depth of field – you may be able to alter the depth of field by the speed of the film you use.

Before the camera sets the appropriate aperture for a given exposure, it has to measure the light level of the subject and take into consideration the film speed. If you are using a fast film that is sensitive to light, the camera can set a narrower aperture, increasing the depth of field. By using a slow film, however, such as ISO 50 or – if your camera can identify it – ISO 25, you can force it to open up the aperture, producing a very narrow band of sharp focus.

Wide Focus

Although a narrow depth of field can help isolate your subject from its surroundings, a more common problem is that the depth of field is too narrow rather than too wide. To capture a scene that has important features at various distances from the camera, you will need a very wide depth of field.

For wide-focus shots you have to vary the same parameters as you would to produce a narrow depth of field – type of lens, size of aperture and subject distance. The wider the angle of the lens being used, the greater the depth of field. Similarly, the narrower the aperture and the further the subject from the camera, the more of the scene that is in focus.

Compact camera lenses

Compact cameras are designed to give you maximum depth of field. The most basic generally have fixed wide-angle

Two points of focus

It is much more difficult to photograph a scene that has two focal points than a scene with only one. The best way of making such a shot work is to place the two important elements on two opposite third points – here the rhino is roughly a third in from the bottom and right, and the children are diagonally up from it.

When a photograph has two important subjects at the opposite third points, joined by a diagonal line in the frame, the eye tends to move back and forth between them, rather than being led out of the frame.

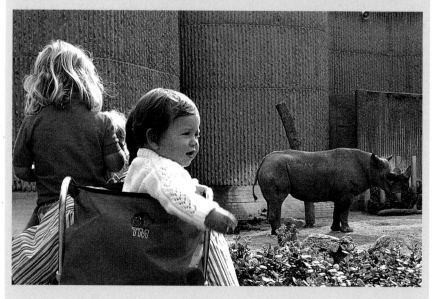

lenses with focal lengths of around 33mm or 35mm. They also have small maximum apertures – often $f/4$ or even $f/5.6$, making it difficult for you to shoot narrow focus shots.

Interesting backgrounds

The most common shooting situation where you need wide focus is when you want to show your child against an interesting background. If your camera allows you to focus manually, you should still focus on your child, but select a very narrow aperture and a wide-angle lens.

This is a lot easier in bright conditions, but you may not be able to use a narrow aperture if the light level is low and you are using standard ISO 100 film. In this case, you should switch to a fast film, such as ISO 400, which will allow you to set a narrower

It is important that the whole scene is sharp, as there are subjects at every distance in the frame. A very wide-angle lens was selected and, because it was a bright day, the aperture could be stopped right down.

aperture. On the down side, you may experience a loss in picture quality.

Fast shutter speeds

If you are using a wide-angle lens, such as a 35mm, you can safely set a shutter speed of $\frac{1}{60}$ second, and maybe even $\frac{1}{30}$ second. Of course, the slower the shutter speed, the narrower the aperture you can set.

If you place your camera on a tripod and make sure your child stands very still, you may even be able to set a slower shutter, such as $\frac{1}{15}$ second. It is possible to handhold the camera at this speed, but make sure you lean against a solid support to shoot.

Focal Length

The most important characteristic that differentiates one lens from another is its focal length. In simple terms, this is the distance, measured in millimetres, between the lens and the focal plane (where the film lies).

Lenses as short as a 6mm are called fisheyes. They take in an angle of view that is greater than 180° and produce a circular image.

The next group of lenses are the ultra wide-angles (13–24mm). Ultra wide-angles give extremely wide depths of field, but can give distorted images towards the edge of the frame.

More common are the wide-angles (28–35mm). These give a generous depth of field and wide coverage, but they are less prone to distortion than ultra wide-angles.

Standard lenses (around 50mm), give a similar perspective to that of the human eye, with everything in the frame appearing in proportion.

From 70mm upwards are the telephoto lenses. The longer the focal length, the greater the magnification. Perspective compression is greater too, so that objects further away than your subject appear to be just behind it.

Depth of field is greatly reduced with telephoto lenses, so that long telephotos (400mm and greater) give very narrow bands of sharp focus.

Left: Wide-angle With a 28mm lens the image in the viewfinder is much smaller and takes in a wider field of view than when you look at the scene normally. Everything in the scene is sharp.

Right: Telephoto Changing to a 200mm telephoto lens, the depth of field is reduced and the perspective is compressed. Notice how, although the leaves are blurred, they appear closer to the statue.

Compact lenses

Most compact cameras with fixed lenses have wide-angle lenses fitted. Some models are known as twin-lens. They offer two focal lengths, often a 35mm wide-angle and a 70mm short telephoto. More advanced compacts have zoom lenses built in. The standard offer 35–70mm or 35–80mm zooms, while others offer longer ranges, such as 35–135mm. The maximum apertures on compacts tend to be smaller than those available for SLRs.

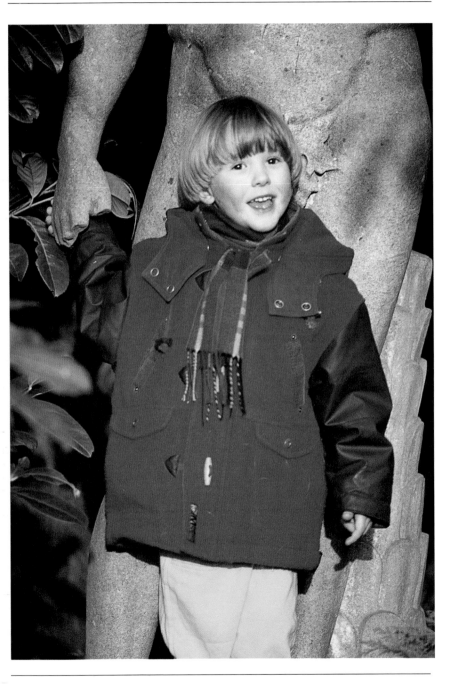

Camera Height

Although it is always easier to hold the camera at your own head height to take a photograph, portraits generally look better when they are taken from the subject's head height. This is easy with adults, whose head height will probably be the same as your own, but for children, it means you have to crouch down.

If you are photographing children playing with toys on the ground, this may mean getting down even lower.

When you shoot from above, you are in danger of distancing the person looking at the photograph from the subject, with the result that the shot is less interesting.

As a general rule, you know you are shooting from the correct height when you are holding the camera level.

Into the child's world

The two pictures on this spread show the same child fastening his shoe. The one opposite is taken from above, with the camera pointing down. Although this is the position from which you might naturally see the child, the shot lacks contact between the child and the person looking at the photograph.

When you take a picture from a child's height, you bring the person looking at the photograph into the child's world. In the shot below, this is reinforced by eye contact.

When you crouch down to shoot from the child's height, the viewer's interest is automatically engaged. Anyone looking at the picture will feel more involved in the child's efforts to fasten his shoes.

Unusual Angles

In most instances you should aim to photograph children from their own height. As a general rule, the closer the camera is to the child's head height, the more anybody looking at the picture is likely to associate with the child.

Nevertheless, if you photograph from above or below, other factors come into play. For instance, shooting a subject from above can emphasize its vulnerability. This can make adults seem weak or worried, but it has the effect of making babies appear cute.

Adding strength

Looking up at a subject has the opposite effect, reinforcing their strength and apparent power. Since children are smaller than adults, it is unusual to photograph them from below, but the result can be both effective and humorous if used in the right circumstances.

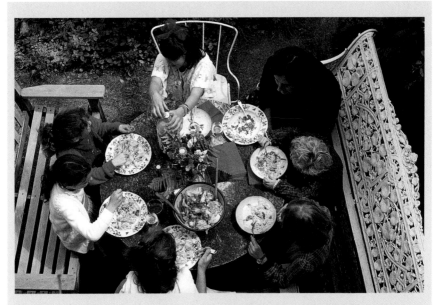

Bird's-eye view

Rather than looking down slightly on a subject, you can choose a shooting position, such as a balcony or a window, that allows you to shoot straight down on your subject. Such shots are sometimes called bird's-eye view shots, for obvious reasons.

When you look down on a subject, you are going against the principle of adding depth to a scene, as you are turning a three-dimensional location into a two-dimensional one. It is important to make sure there is a variety of colors and textures in the shot to create an interesting pattern.

Shooting up at an acute angle is often called a worm's-eye view. It is appropriate here, as the child has dressed up to look strong and powerful. The fact we know the subject is a small child adds a pleasant humour to the shot. Notice how the location has been chosen so that the diagonal lines in the shot lead to the child.

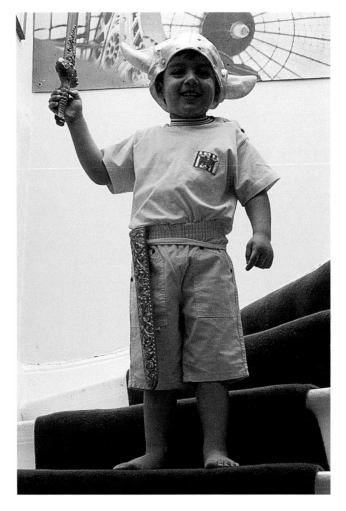

The best time is when a child is pretending to be strong – for instance, dressed up as a superhero. The effect is lost if you shoot from above.

Even taking the picture with the camera held level will produce only a neutral view. But shoot from below and you give the impression that the child is taller than the person viewing the photo. This is reinforced by the fact that objects in the background will be lower than the child because of the angle of the camera.

Be careful when you are taking a shot looking up at a child and you are outdoors. If the background is dominated by sky, you might find yourself with a backlighting problem.

Full-length Shots

Although most portrait shots concentrate on the child's face, a full-length shot enables you to show the whole child. This is particularly important if they are engaged in an activity that involves their whole body, or if they are dressed up and you want to see their whole outfit.

The drawback with full-length portraits is that the child's face is small in the frame and so you may lose their expression. This is more likely if the background is cluttered and contains elements that can draw attention away from the subject.

If you can't find a clear background, try de-emphasizing it. You can achieve this by either setting a narrow aperture to throw it out of focus, or by crouching down and angling the camera up slightly – this might give you a clearer background.

Before you take the picture, scan the image to make sure there aren't any objects butting into the side of the frame. Similarly, make sure that the child is fully in the picture area. An otherwise perfect photograph can be spoiled by a child's foot or hand being cut off by the edge of the frame.

Relaxed expressions

Full-length shots can often look very formal. This is because the child's stance is important, not simply their expression. Try to take the photograph when they are relaxed. Avoid asking them to stand upright or to grin in an unnatural way, otherwise the shot will look stilted. If you take a shot of two children, try and reduce their height difference if there is one – for example, by having the shortest stand on a step. The composition will look neater if they overlap, rather than if there is space between them.

Left: Achieving a natural pose for a full-length shot can sometimes be difficult, so here the toddler has been given a ball to hold. None of the child is butting out of the frame, and a little space has been left around him in case he moves.

Right: Full-length portraits are particularly appropriate when there is a special reason for including the child's outfit – such as here, where she is dressing up. Even though this was shot inside, the least distracting background was found.

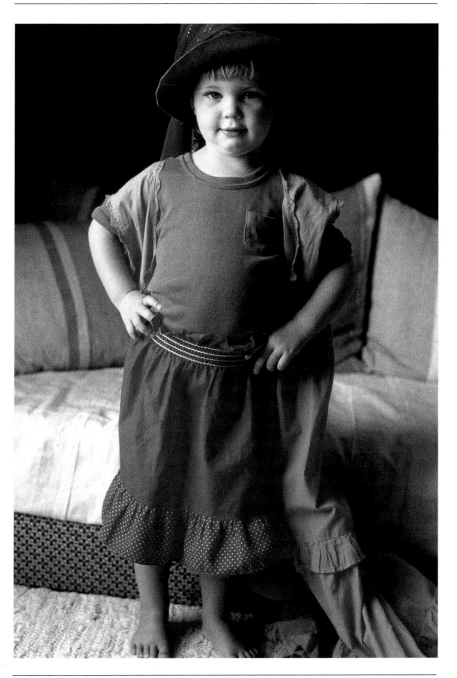

Close-up Portraits

The most expressive parts of a person are their eyes and mouth. As long as these are included in the frame, the photograph will still be recognizable as that person. Shots where the frame is filled by a child's face pack a lot of impact.

Type of lens is important when shooting a big close-up. Just because telephotos magnify the image, it doesn't necessarily mean you will be able to fill more of the frame with the subject if you use a longer lens – the close focusing distance is important too, and you may find a standard lens will get closer than a short telephoto.

With basic compacts you are unlikely to be able to shoot a big close-up. However, you can take a photograph at the camera's close focusing distance and enlarge the appropriate part of the negative later.

Parallax error

With SLR cameras, what you see in the viewfinder is a fairly accurate indication of what will appear on your photograph.

With compacts, the viewfinder is separate, and is often above and to one side of the lens. With most subjects, this doesn't matter, as the perspective from the viewfinder is similar to that from the lens.

With very close subjects, the difference is important, and the framing can be wrong, with the subject appearing slightly to one side and lower in the frame than you had planned. This is called parallax error.

To overcome this, most compacts have a smaller rectangle in the viewfinder with its centre slightly lower and to the right of the centre of the large rectangle usually used to help you compose the picture. With close subjects, compose using this frame.

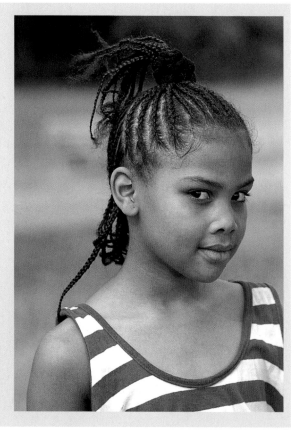

If you have a choice of lenses, choose a telephoto rather than a wide-angle. Using a wide-angle lens close-up will distort your subject's face and should only be used for comic effect. A telephoto is far more flattering.

Focus on the eyes
When you shoot close-up, depth of field will be severely limited. Try to stop down the aperture to give you a wider band of focus, and always focus on the subject's eyes – as long as they are sharp, the shot should be fine.

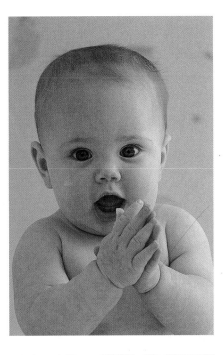

Below: Because the girl has just had her face painted, it makes sense to crop in close on the face, rather than shoot a more usual head-and-shoulders shot.

Right: Depth of field can be very narrow when you photograph a subject from close range. To ensure the shot works, focus on the child's eyes.

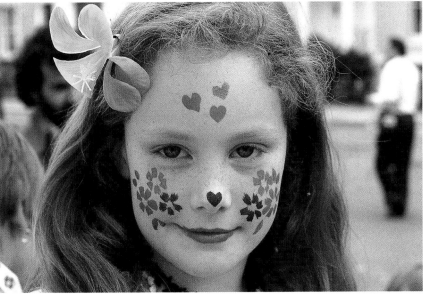

Natural Portraits

Good photographic opportunities can arise whenever you are in an interesting location or your child is engaged in an absorbing activity. But you can also set up shots yourself in order to capture a simple portrait of your child. Take time to think the shot through before you take it.

When planning a portrait, it is important to take the child's character into consideration. For instance, if your child is a keen sports fanatic, it may be more appropriate to let them dress in their favorite clothes rather than force them to wear a suit they may not feel very comfortable in.

Similarly, choose a suitable background. If they have an interest in model airplanes, for instance, take a shot of them sitting among their collection.

Appropriate backgrounds

Don't let the background dominate the shot. Appropriate backgrounds and props should add flavor to the photograph, not become the main subject themselves. If a particularly suitable background doesn't come to mind, find a plain background, such as a painted wall or a curtain.

Your child should feel relaxed about having their portrait taken. Talk to them about what you want, and ask

Despite the natural inclination to have the child look at the camera, the best shot was taken when the girl was looking down.

The girl's entire expression – the way she is holding her lips slightly parted and her head down – is one of deep contemplation.

Eye contact

When we look at a portrait, our attention is almost always drawn to the eyes. Test this with the photograph on the opposite page – look at it for a few seconds, and notice how your attention settles on the girl's eyes. The safest option when taking a picture is to have the child stare into the camera lens, making contact with whoever is viewing the picture. Even potentially mediocre shots can look striking if the child is staring wide-eyed out of the shot.

Occasionally, you can take a risk and ask the child not to look at the camera, such as in the shot on this page. A pensive look was desired, and this was reinforced by the child looking down.

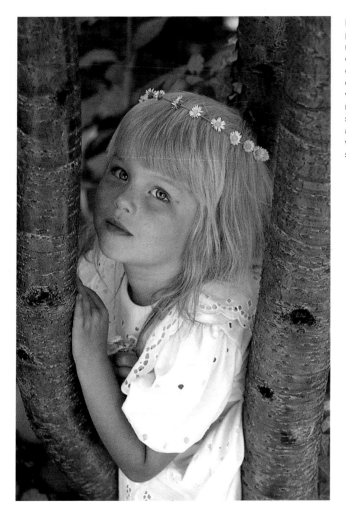

For a girl who likes playing outdoors, nestling in the branch of this tree was an obvious location. The daisy chain garland was an inspired last-minute addition that suited both the child and her clothing, as well as the sylvan surroundings.

them what they would like included in a shot. You don't have to say when you are going to take the pictures – let them know when you are ready, but not when you press the button.

Take several shots – when you've gone to the effort of setting up a portrait, it's not a waste to shoot a dozen or more pictures to get the one where the expression is perfect and where the child has adopted their most relaxed pose.

Timing is important too. Don't press-gang your child into having their photograph taken if they're not in the mood. Set up the shot, and wait until they are happy to be photographed.

Formal Portraits

The key to a professional-looking portrait is lighting. Although you may be able to arrange natural light or flash to a limited degree, the most versatile lights are professional tungsten halogen lamps.

Their principal advantage over flash is that you can see exactly what you are getting before you take the shot. For these shots, 800W redhead lamps were used. You only need one lamp and a reflector for a basic portrait, but two gives you more versatility. Use tungsten-balanced film with tungsten lamps, although you can use special daylight conversion filters, known as dichroics, over them. These balance the lamps for daylight film.

Tungsten lamps can produce a very harsh light, so a piece of special heat-resistant diffusion material was placed over the lamp to soften it.

The basic approach. A tungsten lamp acts as a key light to illuminate one side of the girl's face, while a reflector acts as a fill light, bouncing light from the key back at the girl. Move the reflector back and forth until you get the right degree of modelling.

A second lamp was used as a setting light, shining directly at the background. A cardboard 'flag' was placed between the lamp and the subject, to stop any stray light falling on her. The light was shone through a branch to create the pattern.

Handle with care

Tungsten lamps are very fragile, so handle them with care. Don't move them while they are on. Turn them off and let the bulbs cool down first. Even when cold, the bulbs are fragile. Don't touch them with your hands. Instead, always use a cloth to pick them up.

Lamps get very hot in a short space of time. Unless you have one that is fan-cooled, turn them off between shots. If you are using more than one, check with an electrician to make sure you are not overloading one of your circuits.

Don't use photographic lamps in damp places and – probably most important –

be very careful of the cords. If you can, tape them down so you don't trip over them and send the lamp flying.

Warn everybody before you switch a lamp on – you want to make sure that no one is staring at the bulb when it lights up. Tungsten lamps are usually cheap to rent, although you may have to leave a large deposit.

The Hollywood portrait. The first lamp remained the key light, but the reflector was removed, so there was no fill-in on the face, giving a more dramatic portrait. The second lamp was used as a backlight – above and behind the girl. This gives texture to her hair and provides a halo to make her stand out from the dark background.

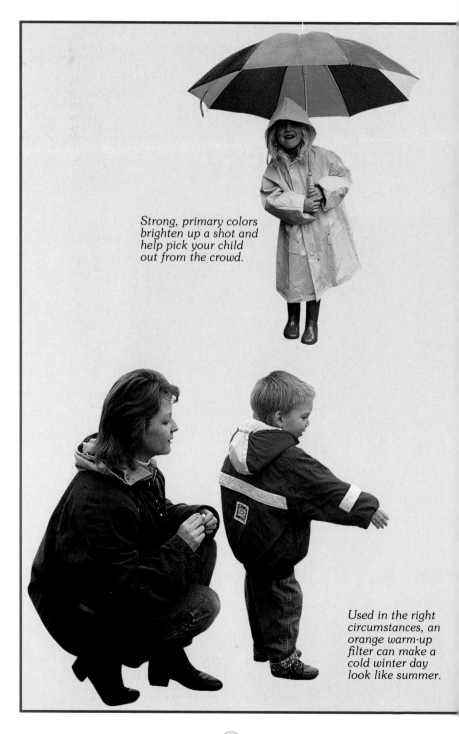

Strong, primary colors brighten up a shot and help pick your child out from the crowd.

Used in the right circumstances, an orange warm-up filter can make a cold winter day look like summer.

Chapter 5
USING COLOR AND FILTERS

- The Color Wheel
- Color Association
- Complementary
 Colors
- Color Saturation
 - Silhouettes
 - Color Filters
- Effects Filters
- Black and White

Strong colors such as red pack a lot of impact, especially when they are placed against a green background.

The Color Wheel

Some color combinations have tremendous impact. Others look drab and lacklustre. Some colors can make a scene look bright; others conjure up a sense of calm or sadness. After an understanding of light and composition, the next most important thing to learn is how to use colors to enhance your photographs.

The diagram on this page shows a color wheel. The reds, oranges and yellows are adjacent on the wheel and are referred to collectively as warm colors. The purples, blues and greens are cool colors. Each color has a particular mood associated with it.

Combining colors

Colors next to each other on the color wheel often go well with each other, without competing for attention. They are said to harmonize with each other.

Colors opposite each other on the color wheel are called complementary colors. Warm colors tend to have greater impact than cool colors, but they appear even bolder when positioned against a cool background.

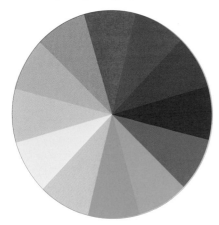

Left: Arrange the colors of the rainbow in a circle and you get the color wheel – a guide to which colors harmonize.

The strong red gives this shot a great deal of impact. The blue lines lead the viewer's eye to the girl's face. Eye contact and the close cropping add to the impact.

A bright color, with warm, summery associations, yellow is the perfect color for a baby shot. The harmonizing white conjures up childlike innocence.

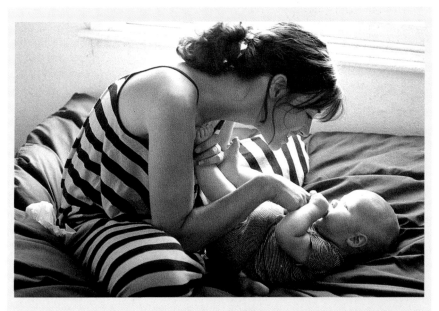

Monochrome set

Scenes containing predominantly white and a single cool color can look almost black and white – especially if any other colors in the scene are very pale. With the pale skin tones hardly competing for attention, the shapes and patterns, such as the diagonal arch of the mother's back, the shape of the two heads and the stripes on her top, dominate the image. When colors are subdued, patterns and shapes become far more dominant – a bright color in this scene would have pulled attention away from the patterns to the brightly colored subject.

Color Association

You can select the clothing your children wear – and the background you shoot against – to include colors that best complement the type of shot you are aiming for. Some colors invoke a stronger reaction than others. A bright red, for instance, has enormous impact.

Heart rate and other physiological functions actually increase when we see a large area of red – psychologists put it down to a primeval association with blood. Red supposedly triggers a 'fight or flight' mechanism in the brain – both activities benefit from quick physiological response times. It thus complements strong action

photographs or shots featuring exciting subject matter.

Yellow and orange are also colors often associated with energy and excitement. Yellow conjures up images of summer and is good to include in shots where the child is cheerful and engaged in a fun activity.

Cool colors
The cool colors have a more relaxed feel. Blues and greens are well suited to shots where your child looks thoughtful, or is engaged in a restful activity. However, the intensity of the color is also important – bright blue summer skies have a strong impact, for instance, whereas pale greens are easy on the eye.

People have their own views about which colors they like – you have to make up your own mind when you take the photograph whether the combination of colors in the scene looks good to you. The important thing is to look at a scene with an eye to the colors before you shoot.

The pictures here feature strong primary colors. Colors next to each other on the color wheel go well together, but so does a combination of primaries – red, blue, yellow. Even on dull days, photographs can be full of impact if your child is dressed in strong colors.

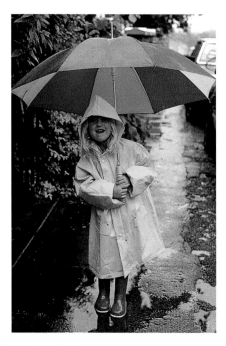

Poor weather might make the possibility of taking a bright shot seem remote. However, strong primary colors have rescued the day and helped produce a vibrant photograph, full of impact.

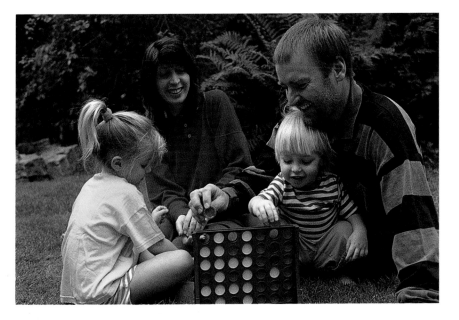

Left: The colors are so strong in this shot that they almost dominate the picture. The strong shapes make an unusual background – but notice how the 'progressive' yellow ring appears to be closer than the blue canvas in front of it.

Above: A powerful combination of primary colors, but it is the triangle of warm colors – the mother's top, the daughter's top and the game they are playing – that draws the eye. The father almost blends into the background – despite his size in the frame.

Making progress

Warm colors are said to be 'progressive' – which means they appear to be closer than they actually are. Cool colors, on the other hand, are known as 'regressive'. This means they seem further away. This property of colors works in photographs too. Red and yellow tend to jump off the paper, while blues and greens often fade into the background. This means that progressive colors look even stronger against a background of regressive colors.

Complementary Colors

Colors that are opposite each other on the color wheel have a very special relationship with each other. When two complementary colors dominate a scene, the contrast can produce dramatic results.

The impact of a color is strongly influenced by the colors around it. Not only do warm colors stand out against cool colors, but also colors are stronger when set against their complementaries.

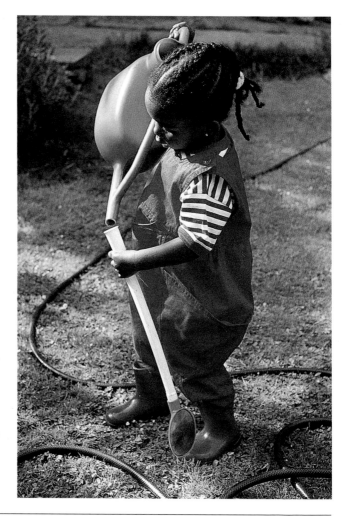

Green and red – the classic contrasting color set-up. Green is such a common background that you only need to dress your child in red to produce a strong image. Always be aware of the background color before you shoot – your child will be lost if they are shot against a backdrop that is the same color as their clothing.

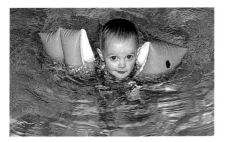

When you shoot blue and orange, you are most likely to be photographing a child dressed in orange against blue sky or water. Because of the strength of orange, a small amount often works best.

Red and green are the easiest complementaries to shoot together, because of the proliferation of good green backgrounds. If both the red of the child's clothing and the green of the foliage in the background are strong, then the result will be a high impact shot.

A strong orange is a more powerful draw on the eye than most blues, so shots often look more balanced if there is less orange in the scene than blue. Yellow and purple are both vibrant colors – when they are the only two colors in a scene, the result can look very dynamic. If you dress one child in one complementary color and another child in the other, the effect may be lost if they are not shot against a neutral background.

Below: The diagram shows those colors that complement each other – red/green, blue/orange and yellow/purple.

Right: Purples and yellows can work well together. They don't always work well with other colors – a red here might produce an overpowering combination.

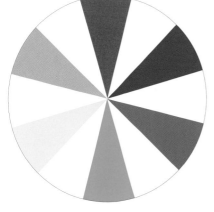

Color Saturation

The colors featured in most of the photographs in this chapter, are all very strong. But colors can also look weak – either because they are inherently weak or because of the lighting conditions.

When a color is at its purest, it is said to be saturated. Colors look most saturated when lit by even, diffused light. If combined with black or white, they become desaturated.

Desaturated colors
You can desaturate a color by overexposure or underexposure – overexposure having the same effect as adding white, and underexposure the equivalent of adding black. Colors can also be desaturated by strong,

directional light, which tends to produce highlights and shadows, both of which desaturate pure colors.

Light, desaturated tones – caused by overexposure, bright lighting or because the color is inherently pale – are known as pastels. In a scene made up completely of pastels, the colors will harmonize, regardless of their hue. Just as warm colors stand out against cool colors, saturated colors stand out against pastels.

Below: Desaturated colors don't have the same associations as pure hues. Pastel shades harmonize with each other and have a relaxed feel.

Right: This shot is dominated by one color. The girl's shirt is saturated orange and stands out against the pastel orange of the background.

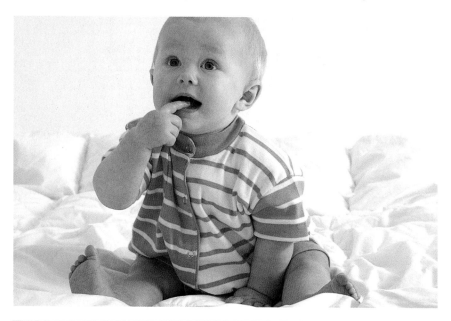

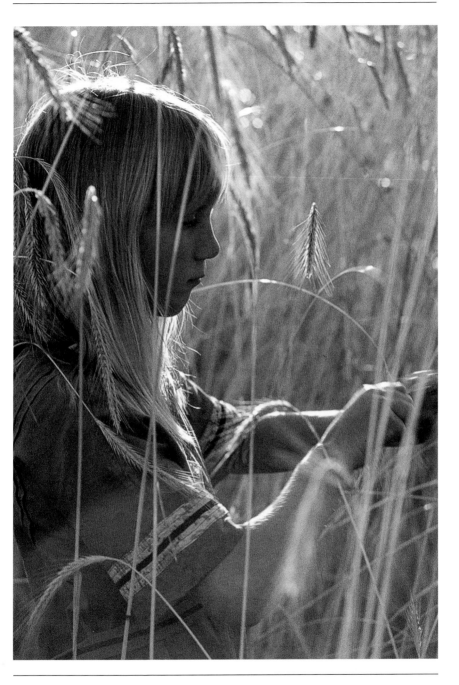

Silhouettes

Occasionally, you may wish to experiment with different photographic techniques. Silhouettes can look striking if the background color is a rich yellow, orange or red, but by silhouetting your child, you will of course lose all detail other than their actual shape.

Sunrise and sunset

The best times for silhouettes are early morning and around sunset – at both times just as the sun is near the horizon. For an effective silhouette, the child has to be backlit – and so in shadow – and the background has to be much brighter than the child is. Often the sun and sky itself will form the backdrop.

Expose for the background. This will be much brighter than the subject, so your child should consequently be rendered completely dark.

If you want to see what a shot will look like as a silhouette before you take the picture, try looking at the scene while squinting. This will give you a rough impression of how the actual picture will appear.

When shooting against the sun, you may be able to hide it behind your subject. This produces a halo around

Silhouettes work well only if the subject is an interesting shape. Here, the child and bicycle are silhouetted against the sun's reflection on water. By shooting them when they are level with the sun's reflection, the edges of the frame are in darkness.

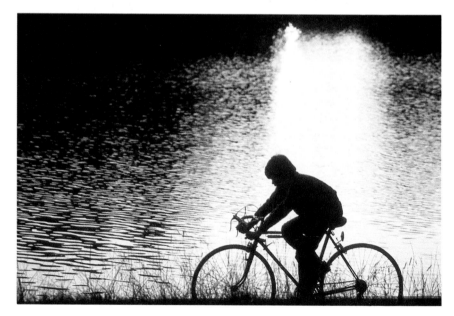

Shortly before sunset is one of the best times to shoot a silhouette. Shadows are long and the land is drenched in a warm glow. The sun directly behind the children has created a golden halo around them. Simply expose for the background to achieve a shot like this.

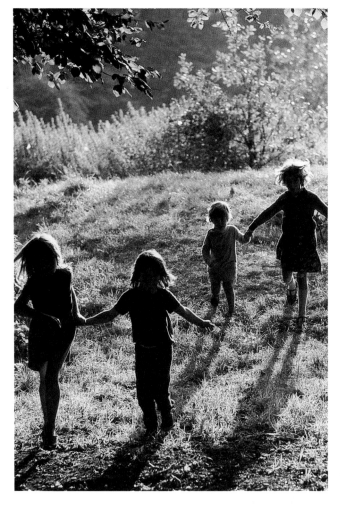

the child and ensures that they stand out from the background.

If the only colors in your shot are black and the sky color, you can create a more dramatic image by placing a color filter over the lens. Orange filters make pale skies a deep golden color, while a red filter can make the scene look truly dramatic.

Watch out!

Be careful when shooting a silhouette not to stare directly at the sun – or you may damage your eyes. This is particularly likely with telephoto lenses, which magnify the image.

For standard or wide-angle lenses, include the sun only if you can stare at it with the naked eye without blinking.

Color Filters

You can alter the look of your photographs by attaching a filter to the front of your lens. You cannot attach filters directly to the front of most compacts, but special filter attachments are available that enable you to use them with compacts.

Various color filters are available, each producing a different effect.

Color correction filters

These balance the film and the dominant light source if they differ.

Daylight, for instance, contains a lot more blue than indoor tungsten lights. If you shoot outdoors with tungsten film in the camera, the result will be very blue. You can correct this by using a deep orange (No. 85B) filter.

If you load tungsten film in your camera to shoot indoors, you may then wish to take a flash picture. As flash is balanced to daylight, you need an 85B. If you are using normal daylight film, but find yourself shooting in tungsten light, a blue (No. 80A) filter will correct the color balance.

Light can be warm or cold depending on the weather conditions, the time of day and the time of year. Notice how cold this scene looks. That's because it was taken on a cold winter day, with no warm sunshine to add a golden cast to the image.

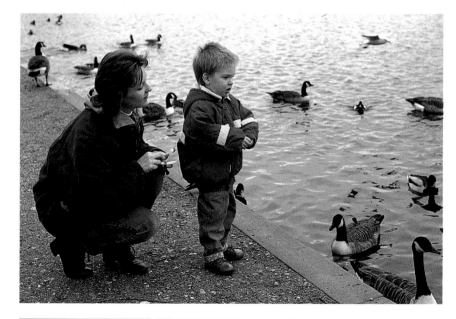

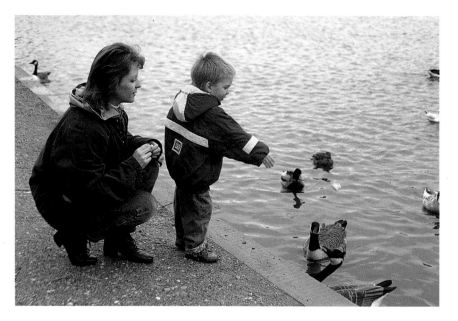

This shot was taken at the same time as the shot on the opposite page, but a No. 81B warm-up filter was attached to the lens.

The effect is to give the scene a warm glow. The effect is not unnatural, but it does make the scene look warmer.

Warm-up filters

The shot here shows the effect of a milder orange filter (No. 81B). The 81 filters are often used to make a scene look warmer and to make pale skin tones look healthier.

The shot on the left shows the child feeding birds on a cold winter day, while the one above shows the same scene with a No. 81B. The shot now looks as if it was taken on a sunny day.

Color effect filters

These are used to add an overall color to a scene, and you should limit their use, as the effect can look unnatural.

Graduated filters are half clear and half colored. You can use them to give a dramatic color to the sky.

Creative Colors

The filters used for black-and-white photography come in a wealth of rich hues. Sometimes one of these can make a brilliant addition to your color pictures. Naturally, the color of the filter determines the cast of your picture. Exposure does need to be adjusted. It is wise to increase exposure slightly; experiment to see what is pleasing to you.

Effects Filters

One of the yardsticks by which a photograph can be judged is the sharpness of the subject. This is not only a function of good focusing, but is also dependent on the quality of the lens. Nevertheless, filters are available that make the subject less sharp. Although the lens should still be focused on the subject, soft-focus filters diffuse the light passing through them, reducing contrast and softening the image.

Although soft-focus filters are often used to soften wrinkles and facial lines on adults, they are also suited to photographs of babies, reinforcing the impression of innocence, or on young adults to add a touch of glamor.

Diffusion filters
The least noticeable effects are gained from diffusers. These hardly soften the image at all, but they lower the contrast to produce less harsh results. Colored diffusers are available – usually in pastel shades. Fog filters give far more dramatic results, making the whole scene look misty.

Nothing wrong with this, but a soft-focus filter may add a dreamy quality that is difficult to attain when the subject is sharp.

With a soft-focus filter, the whole image is diffused, even though the lens is still focused on the girl's face. This adds a romantic feel.

Center-spot diffusers keep the subject sharp, but soften the edges of the frame to isolate the subject. Center-spot diffusers work best when the edges of the frame are uncluttered. Whenever possible, use a wide aperture to narrow the depth of field – this blurs the border between the sharp and soft parts of the frame.

These can be a little overbearing for portraits.

You can also opt for a center-spot diffuser. These are clear in the center, but they diffuse the light at the edges of the frame. When you use a center-spot, place the child's face in the center of the frame. The diffused outside draws attention to the face.

Diffusion filters work best under diffused light. The effect is often exaggerated when you use a wide aperture or telephoto lens to reduce depth of field. Center-spots work better at wider apertures too – if you stop right down and use a wide-angle lens, you can see a distinct circle where the diffusion effect starts.

Black and White

Photography began as a black-and-white medium, and only later became dominated by color. Even now, important photographic media, such as newspapers, rely on at least a proportion of black-and-white photographs.

Although most hobby photographers now use color exclusively, it is worth experimenting with black and white – especially if you want to create an atmospheric or nostalgic feel.

Black-and-white printing can be expensive, as most labs only process color print film. At a professional lab, you may have to order each print individually.

The importance of tone

Tone becomes important in black-and-white photography, as you no longer have color to separate one form from another. Green and red are opposites on the color chart, but they can be similar in tone, and may even merge.

Try to visualize the scene by looking at the brightness of the elements, rather than what color they are. Shape, too, is more important in black and white than color, so look out for subjects with simple, bold forms.

Black-and-white photographs can look far more dramatic than color. The expressions on the faces of the children are so good in this shot that splashes of color might have been distracting.

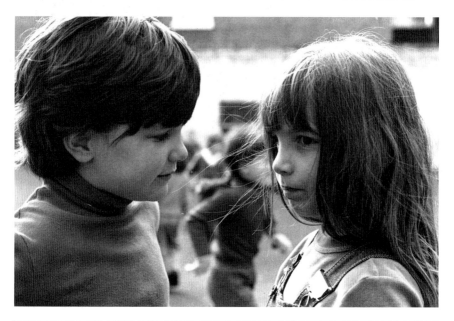

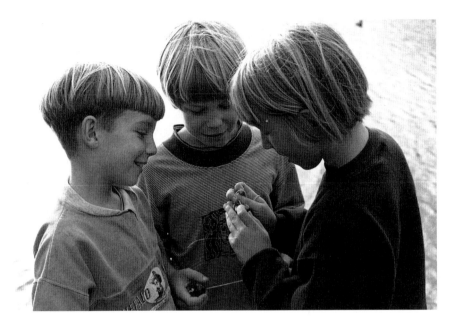

Above: The bright colors of the boys' sweaters and the overbright background could have proved distracting had this been shot in color.

Right: Throwing the background out of focus can be very effective with black and white. Here, the clutter behind the baby is a grey blur.

Color filters

Color filters can be used in black-and-white photography to change color tones. A color filter will make objects of the same color appear lighter and opposite colors appear darker – so an orange filter will lighten skin tones, but deepen blue skies.

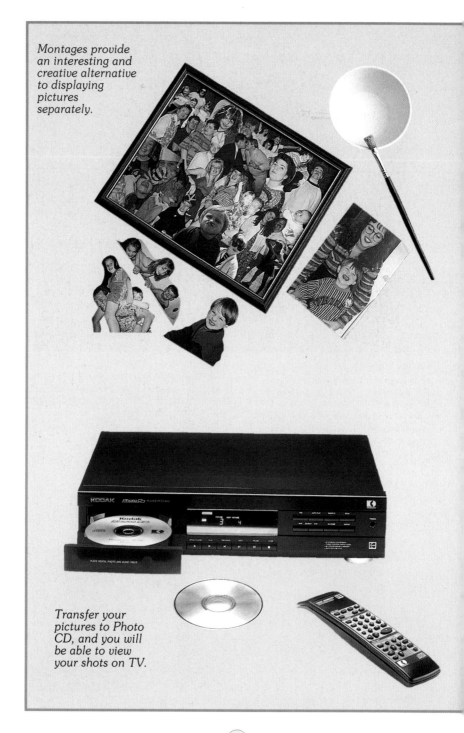

Montages provide an interesting and creative alternative to displaying pictures separately.

Transfer your pictures to Photo CD, and you will be able to view your shots on TV.

Chapter 6
PICTURE PRESENTATION

- Cropping
- Display Methods
- Viewing on TV
- Photo Gifts

Some processing labs offer a service that combines different shots on to one print, and allows you to include your own captions or messages.

Cropping

In an ideal world, you would have plenty of time to make sure every shot was perfectly composed before you pressed the shutter release. But in reality, you often have to grab action as it is happening – which can result in poor composition.

In some instances, you don't spot the best composition until you get the print or slide back from the processors. Perhaps you could have moved a bit closer, to crop out the distracting blue post box you didn't notice when you took the picture, or to eliminate too much headroom.

You may belatedly realize that what you took as a landscape format would have in fact been a lot more striking with a portrait crop, the distracting elements at the sides removed.

In these instances, you may be able to improve the shot by recropping it , either by taking a metal ruler and a scalpel to the print, or – more professionally – by taking the negative to a photo lab.

Take a print with you, with the desired crop drawn firmly on it. The lab will then be able to make a selective enlargement of this area, cropping out all the unwanted elements. Remember if you greatly enlarge part of a negative, the quality of the print will be reduced.

Panoramics

There may be times when the 3x2 format of 35mm prints and slides is not the best shape for your subject. In this case, instead of recropping the print, you may want to choose a format that is more appropriate to your subject. A small number of compacts now contain a panoramic option, which gives you a much wider shot relative to two conventional 35mm frames. If your camera doesn't offer this feature, you can still take panoramic shots by using the KODAK FUN SAVER Panoramic 35 Camera.

Such wide views are useful for scenes that don't have a specific focal point, but which have a number of subjects or actions taking place within them.

Panoramic shots are particularly suited to very wide or very tall subjects, but also for rows of children. You can then concentrate on their faces, rather than on less interesting parts of the scene.

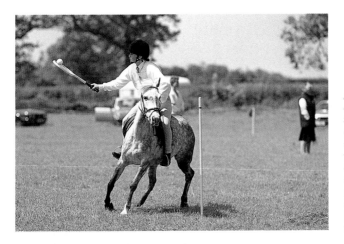

Although the shot was originally taken on a 35mm format camera (left), elements at the side of the picture were thought to distract from the main subject. By asking a photo lab to make a selective enlargement, (below) a better print was produced.

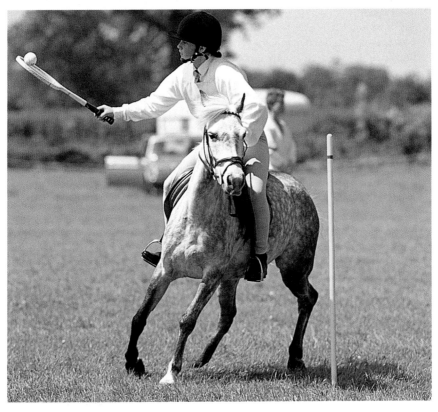

Display Methods

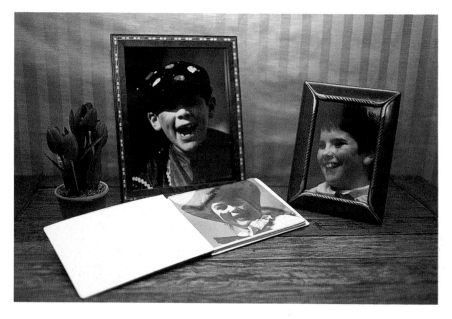

Most photographers accept that on every roll of film they have developed there will be a number of photographs which, for one reason or another, are unsuccessful. The first step in having a good collection of photographs that people want to look at is to realize this and put aside – or throw away – those that don't work.

Protecting your prints
The next stage is to find a method of displaying the successful photographs. Passing round a handful of prints is unsatisfactory. Apart from the fact that only one person is able to look at them at any one time, they will soon become grubby and covered in fingerprints.

Frames are available in hundreds of styles and dozens of sizes. Pick those that don't overshadow the picture, and which complement your decor.

Probably the easiest way of viewing the shots is by placing them in an album. Look for one of the larger types that allows you to display four standard-sized prints on a spread. Ideally choose one with a plastic overlay to protect the prints.

Vary between landscape and portrait, so that all the pages don't look the same. Varying between different sizes of print will also make the display look more dramatic.

You may want to mount and hang some of the better shots. Ready-made frames are available in all usual print

sizes, but choose a glass-covered type to prevent the prints being damaged.

Displaying slides

If you use slide film, it may be worthwhile buying a projector and screen, Slides always look richer and brighter than prints, because you are seeing direct light shining through them.

The standard slide projector is the carousel type, which holds 80 mounted slides. With a remote control unit, you can move the carousel forward or backwards, and alter the focus.

Montage techniques

Instead of displaying your photographs individually, you can put in a little time and effort and create a montage of different subjects within the same frame.

The simplest photographic montages involve sticking overlapping prints on a wall-mounted display board. A more creative approach is to cut out the people from your shots and stick them on to a large piece of card, leaving no spaces between.

These can then be placed in a photographic frame to provide a single image with multiple points of focus. You can include shots of your children and family at various different ages, so that a shot of your child as a baby might be sitting next to a shot of them at eight.

You don't have to make the montage look as if it were a single photo – like the cover of the Beatles' famous album Sgt Pepper's Lonely Hearts Club Band. *Vary the shot sizes and image sizes throughout.*

Dark background

Stick the pictures on to a piece of black card first, as this won't cause a distraction if there are any spaces between prints. Use a simple paper glue and start sticking the photographs at the top of the card first. Arrange them as you want them before you stick them down.

Viewing on TV

With a KODAK Photo CD Player you can take your best photographs and have them stored digitally on a gold compact disc. There are a number of reasons why you might want to do this.

First, you may simply wish to view your pictures on TV – although the quality of a TV screen may not do the shot justice, this method of viewing does have the advantages that the image is large, and that a number of people can view each picture at the same time.

The discs need special players in order for you to be able to view them. A number of CD players are available, one is even portable.

However, other new multimedia CD formats, such as CD-I, also play back photo CDs. All of these players play back conventional audio CDs too.

Photo CDs also provide a neat way of filing your best pictures. As the CDs retain the photographic quality, the discs can be used as negatives – you can take the CDs along to a lab to have more prints made, rather than having to sort out the easily damaged negative.

Computer Images

Yet another way to capture images is by using a digital camera, such as the Apple QuickTake 100. It is a method to take pictures and display them on your computer. This new electronic point-and-shoot camera was developed using the digital image capture technology of Kodak and the understanding of the people who use computers by Apple Computer.

Once images are captured using the Apple QuickTake 100, they can be transferred or "downloaded" into your computer for viewing and manipulation. This manipulation (for cropping, etc.) requires photo-enhancement software, such as Adobe Photoshop ®. Furthermore, the image can be output in print form with the appropriate printer. The uses of this camera, like Photo CD, are endless.

® Apple QuickTake 100 is a registered trademark of Apple Computer Inc.

Photo Gifts

Advances in electronic imaging now enable us to see photographs in forms other than straight prints, slides or on TV. A photograph can now be stored as an electronic signal, then printed on to items such as T-shirts, mugs, mats and drink coasters – which can make fun presents.

This shot was scanned and a standard template was placed over it. Using a pre-designed template usually works out cheaper than drawing up a dedicated design.

A montage of shots can also be created using electronic imaging. The words were inserted over the shots to complete the image. This was then printed out as a single image, ready to be framed.

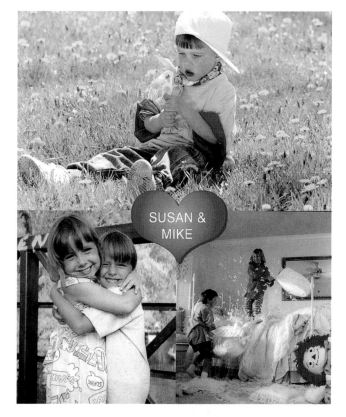

SUSAN & MIKE

Although you could print on to cards or fabrics using conventional printing methods, the work involved often makes the unit cost prohibitively high – unless you are printing several hundred items.

Electronic printing methods, where the photograph can be scanned fairly cheaply and then manipulated on a computer, work out much cheaper for short print runs than conventional methods. This makes printing a couple of dozen party invitations or birthday cards using one of your photographs relatively inexpensive.

Companies are busy producing machines that can scan one of your pictures and output it as a greetings card with a dedicated message printed over it. Some of these machines can also create a montage of images and place a caption over them.

Prices vary depending on whether you want a set template placed over your shot (in which case the cost is no more than a standard reprint) to complex systems that allow you to crop your pictures on-screen, create montages and type in your own text in one of a number of styles.

Glossary

Aperture A variable-sized opening between the lens and the film plane that regulates the amount of light reaching the film. The size of the opening is measured in *f*-stops.

Autofocus (AF) Electronic circuitry within the camera that measures the distance between the camera and the subject, and focuses the lens automatically to ensure the subject is sharp.

Backlight compensation Button found on some automatic cameras that when pressed opens the aperture by about one and a half *f*-stops over the aperture set by the camera. Used when the camera might be fooled by strong backlighting.

Bird's-eye view Acute shooting angle where the camera is pointed down at the subject.

Bracketing Shooting a number of shots of the same subject at different exposures to ensure a correctly exposed shot. Useful in high-contrast situations that may fool the camera.

Camera shake Blurred image caused by subject moving during exposure rather than because lens is focused incorrectly. Cured by setting a faster shutter speed.

Color saturation Degree of purity of colors in a scene. Colors are purest under diffused light. Highlights and shadows, as well as over- or underexposure, cause desaturation.

Compact cameras Cameras that use a separate viewfinder to compose the image. This leads to size reduction, but the user cannot see whether the subject is sharp.

Cut-off point Place where the body is cut off by the bottom of the frame when the whole body is not included. Avoid ankles, knees, waist and neck.

Depth of field The amount of the scene in front of and behind the point where the lens is focused that is sharp – roughly twice as much behind as in front. Increase depth of field by setting a narrower aperture, using a wider lens and/or moving further away from subject.

Dichroics Filters placed in front of tungsten halogen lamps to convert the yellowish light to match that of daylight.

Exposure The amount of light falling on the film. Exposure can be increased by setting a wider aperture and/or a slower shutter speed.

Film speed How sensitive film is to light. ISO 50 film is half as sensitive to light as ISO 100, so needs twice the exposure to register a similar image. Fast film is useful in low light, but is grainier and of poorer quality.

Fill-in flash Flash used in bright situations, such as strong sunlight, to even out the shadows on a subject. Normally used to correctly expose faces in high-contrast lighting.

Fisheye lens Lens with very wide angle of view that produces circular image. Subjects appear very distorted.

Flare Light that is not part of the image reaching the film – such as when you are shooting towards the sun and the sun is only just out of shot. It is characterized by weak contrast and color, and a line of polygons on the photograph.

Focal length In practical terms, the measure of the angle of view afforded by a lens. Wide-angles (up to around 35mm) give an angle of view of greater than 50°. A 50mm standard lens offers a 40° viewing angle, whereas telephotos give much narrower coverage.

Focusing steps Distances to which a compact camera's lens can be focused. The greater the number of focusing steps, the greater the chance of sharp focusing.

Format Two uses. First to denote the film size used by the camera – e.g. 35mm or medium format. Second to describe whether a rectangular shot is taller than it is wide (portrait format) or wider than it is tall (landscape).

f-stops Aperture size is measured in f-stops. The widest possible value is $f/1$. The actual diameter varies depending

on the focal length of the lens. Each halving of the aperture size is known as a difference of one stop. $f/1.4$ is half the area of $f/1$, with the progression running: $f/1, f/1.4, f/2, f/2.8, f/4, f/5.6, f/8, f/11, f/16, f/22, f/32$ and so on. $f/5.6$ lets in half the light of $f/4$ and a quarter of the light of $f/2.8$. An $f/2.8$ lens is one that cannot set a wider aperture than $f/2.8$. However, you can select $f/4, f/5.6$ and so on.

High-key portraits Portraits where slight overexposure causes some details to be burnt out, giving a dreamlike quality to an image. Particularly suited to light subjects.

Hotspots Overbright area of light on a surface that burns out surface detail.

Looking room Compositional technique that suggests more space should be left in the frame in the direction a person is looking than behind them. This way they lead the viewer's eye into the picture, rather than out of the frame.

Macro A macro image is one where the subject is the same size on the slide or negative as in real life. However, the term is often used to mean simply close-up photography.

Modelling Bringing out detail on a subject by lighting from an angle, so that shape is defined by highlights and shadows.

Overexposure Setting too slow a shutter speed or too wide an aperture so that the image is rendered too light.

Panning The action of moving the camera horizontally or vertically to follow a moving subject, keeping the subject at the same point in the frame throughout the movement. The camera moves during exposure, producing a sharp subject, but a blurred background.

Parallax error With compact cameras, the viewfinder is positioned away from the lens. When you are very close to your subject, this can make a slight difference, so that central subjects appear off-centre.

Predictive autofocus Focusing system found on some SLRs that constantly refocuses the lens when the shutter release is pressed halfway. Used to ensure fast-moving subjects are sharp.

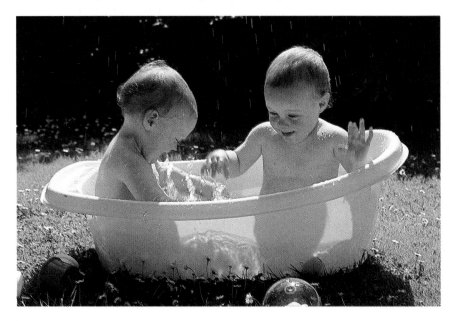

Presence The illusion of depth in a photograph.

Red-eye Red eyes on photographs caused by the proximity of the flash to the lens. Light from the flash is reflected by the pupil into the lens. The angle between the flash, eyes and pupils has to be less than 2° for red-eye to occur, so is less likely with closer subjects or with flash guns that are placed further away from the lens.

Red-eye reduction System built into some compacts that fires a burst of light before the shot is taken. This reduces the size of the pupil and hence the amount of red-eye.

Reflector Any reflective surface that bounces light rays back at the subject. Most reflectors are white, but colored reflectors can be used to add a color cast to the image. Gold reflectors create a warm glow.

Rule of thirds Compositional technique that suggests a subject placed a third of the way in from the edges of the frame looks better than a subject centrally positioned.

Self-timer Feature on a camera that builds in a delay between pressing the shutter release and the shutter firing. This allows the photographer time to get into the shot.

Shutter speed The amount of time the shutter remains open during exposure. As with apertures, a halving or doubling of the shutter speed is known as a stop, so there is a stop

difference between $\frac{1}{125}$ second and $\frac{1}{250}$ second.

SLRs Cameras where light coming through the lens is reflected by a series of mirrors into the viewfinder. This means the image you see through the viewfinder is what you will get on the photograph. Most viewfinders show a slightly smaller amount of the image than is captured on film.

Stopping down Closing down the aperture from its maximum to a smaller f-stop. This increases depth of field, reduces the amount of light, and can improve the resolution of the image. Most lenses perform slightly better around $f/8$–$f/11$.

Tripod Three-legged support on which camera can be rested to ensure a steady image – particularly when using long lenses or slow shutter speeds. Make sure the tripod is sturdy enough for your camera.

Twin-lens compacts Compact cameras with two focal lengths built in (generally a wide-angle of around 35mm and a short telephoto of around 70mm).

Underexposure Setting too fast a shutter speed or too small an aperture, so the subject is too dark. Often an automatic camera will underexpose the subject if another part of the frame is overbright.

Worm's-eye view Shot taken at an acute angle with the camera tilted up at the subject.

Index

A

aperture 11, 20, 45, 49, 52, 53, 59, 65, 66, 72, 85, 91, 92, 93, 94, 95, 96, 102, 105, 125
autofocus (AF), *see* focus

B

background 12, 17, 28, 29, 31, 39, 42, 50, 52, 53, 75, 81, 82, 83, 84, 85, 88, 92, 95, 102, 106, 108, 112, 114, 115, 116, 120, 121, 127
backlight compensation 18, 53
bird's-eye view 100
black and white 53, 113, 126, 127
blur 31, 48, 60, 61, 63, 127
bracketing 138

C

camera height 20, 34, 35, 39, 50, 57, 77, 98, 99, 100, 101, 102
camera shake 61, 65, 71, 73
candid photography 16, 17, 66
CD-I 134
color 100, 112-121, 126, 127: association 112, 114, 115; complementary 112, 116, 117; cool 112, 113, 114, 115, 116; co-ordinating 51, 84, 85; desaturated 118; harmonizing 112, 113, 118; intensity 114; pastel 118, 119; primary 110, 114, 115; progressive 115; regressive 115; saturated 118, 119; warm 53, 112, 113, 114, 115, 116, 123; wheel 112, 113, 114, 118
compact cameras 16, 17, 28, 31, 32, 33, 41, 45, 48, 50, 53, 61, 80, 83, 93, 94, 96, 104, 122, 134
composition 13, 15, 22, 23, 63, 68, 76, 83, 88, 89, 102: auto-composition 83
compression 96
cropping 130
cut-off points 82

D

depth 70, 90, 91, 100
depth of field 38, 52, 56, 64, 65, 66, 91, 92, 93, 94, 96, 105, 125
dichroics *see* filters, daylight balanced
dressing up 102, 106, 116

E

exposure 11, 18, 20, 45, 53, 59, 61, 85, 93, 120: automatic 18, 91; manual 20, 53; programmed 49, 93; over- 11, 48, 53, 59, 77, 118; under- 11, 18, 53, 59, 76, 118
eyelines 22, 25
eyes 15, 22, 23, 25, 99, 104, 105, 106, 112

F

field of view 96
film 11, 18, 49, 50, 56, 59, 61, 95, 123, 132, 134: color 123; daylight 71, 108; fast 61, 66, 71, 76, 77, 93, 95; print 59; pushing 76, 77; slide 59; slow 61, 77, 93; speed 61, 73, 76, 93; tungsten 71, 72, 73, 108, 121
film plane 11
filters 121-124: blue 122; center-spot diffusers 125; color 121, 122, 123, 127; color correction 122; colored diffusers 124; daylight balanced 108; diffusion 124, 125; effects 124-125; fog 124; graduated 123; graduated blue 51; magenta 73; orange 53, 121, 122, 127; pastels 124; polarizing 50, 51; red 121; soft focus 124; warm-up 110, 122, 123
fisheye *see* lens
flags 108
flash 10, 18, 24, 25, 37, 53, 60, 61, 65, 66, 67, 72, 75,

76, 85, 108, 122:
bounced 23, 24, 66, 67,
71, 75; fill-in 48, 53, 92;
off-camera 71
focal point 22, 25, 94, 130
focal length 95, 96
focus 29, 32, 33, 38, 41,
44, 47, 49, 91, 93, 94,
105, 124, 127:
autofocus 17, 32, 47, 49;
close 104; fixed 32;
focus lock 49; manual
29, 32, 44, 46, 47, 95;
narrow 92, 93, 96;
predictive autofocus 49;
prefocusing 38, 44, 46;
wide 94, 95, 105;
see also depth of field
focusing steps 32
foreground 30
formal shots 18
format 30, 80, 130, 131;
landscape 30, 80, 81,
130, 132;
portrait 30, 42, 80, 81,
130, 132
frame 15, 38, 41, 45, 49,
50, 56, 58, 65, 66, 81, 89,
90, 91, 96, 102, 104, 120,
125
framing 32, 44, 45, 58, 88,
89, 104
f-stops 11, 76

G H

grab shots 15, 86
grain 61, 77
group shots see portraits
halo 29, 31, 109, 120, 121
headroom 82, 130
highlights 18, 20, 23, 28,
29, 118
hotspots 20, 75

I

ISO (international
standards organization)
see film speed

L

lead-in lines 91, 101
learning to walk 14
lens 11, 15, 17, 32, 41, 45,
49, 56, 72, 104:
fisheyes 96, 139;
interchangeable 17;
standard 96, 104, 121;
telephoto 17, 29, 38, 40,
42, 47, 56, 58, 65, 71, 73,
83, 91, 92, 96, 104, 105,
121, 125; ultra wide-
angle 96; wide-angle
16, 17, 28, 38, 39, 41, 52,
56, 57, 58, 64, 65, 71, 73,
83, 85, 90, 94, 95, 96,
105, 121, 125; zoom 17,
42, 56, 71, 83, 96
lens flare 29
light 11, 18, 20, 35, 37, 45,
49, 59, 61, 71: back 28,
29, 92, 101, 120; candle
60; dappled 12; diffused
23, 118, 125; harsh 12,
35, 67; high contrast 20;
low 10, 66, 67, 76; side
18, 23; soft 18, 23, 67;
sun 12, 23, 28, 29, 31;
top 31; window 10, 18,
37, 63, 67, 74, 76
lights 71: back 109; fill
108; fluorescent 73; key
108, 109; setting 108;
tungsten halogen 71,
108, 109, 122
location 18
looking room 15, 81, 82

M N O

macro 41
medium format 139
modelling 18, 23, 67, 108
montage 133, 136
negative 104, 130, 135
overexposure see exposure

P

panning 45
panoramics 130
parallax error 104
pattern 16, 108, 113
perspective 91, 96, 104
pets 20
photo album 132
Photo CD 134
portraits 18, 24:
close-up 23, 41, 51, 56,
58, 66, 71, 75, 83, 84,
104, 105, 112; family
24, 25; formal 18, 20,
21, 23, 24, 39, 86, 102,
108, 109; full-length 81,
82, 83, 102, 103; group
22, 23, 24, 56, 66, 86;
high-key 23;
Hollywood 109;
informal 18, 20, 24, 25,
38, 64, 106, 107
presence 90
props 57, 65, 75, 78, 86,
102, 106

R

red-eye 24, 25
redundant space 15, 82
reflectors 35, 66, 108, 109
rule of thirds 15, 82, 94
schools 17

S

selective enlargements 131
self-timer 24
shadows 18, 20, 23, 28, 29, 31, 35, 59, 67, 118, 120, 121
shutter 11, 36, 45
shutter curtain 49
shutter release 11, 24, 45, 49, 81, 84, 130
shutter speed 11, 20, 31, 45, 48, 49, 59, 73, 95; fast 31, 45, 47, 48, 49, 61, 68, 71, 85, 95; flash sync 53; slow 31, 45, 53, 60, 61, 68, 73, 95
silhouettes 29, 75, 120, 121
single use cameras 130

SLRs 17, 25, 31, 32, 38, 41, 47, 49, 66, 80, 104, 134
snow 53
stopping down 85, 105, 125
stops *see f*-stops
sun 12, 23, 28, 29, 30, 67, 120, 121
sunset 121

T

texture 10, 17, 100, 109
35mm cameras 80, 130, 131
time of day 28, 29, 30, 44, 50
time of year 29, 30, 34, 60,

88, 110
tone 126
toys 13, 75, 86, 98
tripod 24, 60, 61, 62, 71, 73, 89, 95
twin-lens cameras 96

U V W

underexposure, *see* exposure
viewfinder 13, 16, 32, 50, 74, 96, 104
waterproof housings 75
weather 28, 114
worm's-eye view 101

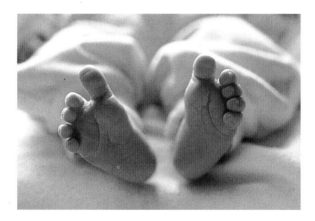